F

10

D1593315

# The
# Entrepreneurial
# Artist

# The Entrepreneurial Artist

*Lessons from Highly Successful Creatives*

Aaron P. Dworkin

ROWMAN & LITTLEFIELD
*Lanham • Boulder • New York • London*

Published by Rowman & Littlefield
An imprint of The Rowman & Littlefield Publishing Group, Inc.
4501 Forbes Boulevard, Suite 200, Lanham, Maryland 20706
www.rowman.com

6 Tinworth Street, London, SE11 5AL, United Kingdom

Copyright © 2020 by Aaron P. Dworkin
Distributed by NATIONAL BOOK NETWORK

British Library Cataloguing in Publication Information Available

**Library of Congress Cataloging-in-Publication Data**

Names: Dworkin, Aaron P., author.
Title: The entrepreneurial artist : lessons from highly successful creatives /
   Aaron P. Dworkin.
Description: Lanham : Rowman & Littlefield, [2020] | Includes bibliographical
   references and index.
Identifiers: LCCN 2019008873 (print) | LCCN 2019019560 (ebook) |
   ISBN 9781538129548 (electronic) | ISBN 9781538129531 (cloth : alk. paper)
Subjects: LCSH: Performing arts—Vocational guidance. | Performing
   arts—Economic aspects. | Entrepreneurship. | Music entrepreneurship. |
   Entertainers—Biography. | Artists—Biography. | Successful people—
   Biography.
Classification: LCC PN1580 (ebook) | LCC PN1580 .D88 2020 (print) |
   DDC 791.023—dc23
LC record available at https://lccn.loc.gov/2019008873

♾™ The paper used in this publication meets the minimum requirements of
American National Standard for Information Sciences—Permanence of Paper
for Printed Library Materials, ANSI/NISO Z39.48-1992.

For my sons,
Noah and Amani,
and my wife and partner in the universe,
Afa

# Contents

# An Introduction of Uncommon Rhythm

I never enjoyed practicing the violin. I found running passages tedious and playing my scales a bore. As a teenager, it was the source of many arguments between my parents and me. Despite my reluctance to practice, however, I always loved music. It moved me like nothing else. While the violin chose me at a very young age, I would come to find that my real instrument was to be discovered much later in life.

As a child, I would sit and watch my adoptive mother, Susan, play her violin. When she drew her bow across the strings, the music of Bach would cascade out, bathing the room in splendor. Like a kind of magic, the music poured deep into my soul, filling me with a sense of beauty and wonder. The sound forged a connection between my mother and me. I would cry when I heard her play—as if I had been filled to the brim and the music was pouring out of my eyes. I yearned to be able to speak in the voice of the violin.

So I began taking lessons with my first violin teacher, Mr. Graffman. A no-nonsense Russian immigrant, Mr. Graffman was a tough teacher to please, but I was stimulated by his rigor. During every lesson, when I would goof off, he'd reprimand me with a stern "*You no talk. You play.*" I admired this strict approach to craft. With Mr. Graffman, I excelled quickly, developing what he called a "unique talent." By the age of ten, I'd been elevated to the concertmaster of my local youth orchestra.

But as I grew older, practicing once again became a routine I abhorred. Despite my great passion for the instrument, I found that rote rehearsals were drudgery I had to endure. I'd devise ways

to trick my parents into believing I was practicing: I'd play reel-to-reel recordings of myself going through technical passages. When they discovered the tapes hidden in my bedroom, I learned to read while playing, carefully turning the pages of a novel with my foot. Feeling that I had gotten all I could from playing violin, I knew that I was searching for something else. My music felt like a soundtrack to the rest of my life.

As artists, so much has to come from within, out of our selves. We need to be self-driven, self-funded, self-inspired, and self-aware. Sacrificing ourselves for our art can be exhausting. Whether it is the proverbial ten thousand hours of practice you must put in or writing a grant for ten thousand dollars, artists need to hustle if they want to succeed. The reality is that the fulfillment of creative or artistic dreams does not happen by accident. There must be a constant mentality of problem solving, of looking at challenges as mysteries to be revealed and riddles to be unraveled rather than barriers to success. Artist-entrepreneurs must be creative sleuths deploying innovation in pursuit of realizing their artistic dreams. Persistence is fundamental to being a successful artist. As a young person, I did not fully understand the work ethic and grit that regular practice on the violin had instilled in me, though the connections were made much more clear to me as I continued on my journey.

Today's world is one of start-up businesses and venture capitalists disrupting industries and breaking down silos in the name of profit. This can feel like a cold world to most artists, who are motivated not by new profits but new perspectives, new emotions, and new experiences. But our art is not just our passion; it's our start-up business.

Having started a handful of nonprofits, I understand the risks and pitfalls that come with entrepreneurship. Indeed, many of my organizations failed due to unforeseen circumstances. But artists—perhaps more than anyone else—are keenly aware of risks. We encounter them every day in our efforts to be better, perform better, and create better. Risk is inherent to the pursuit of our passion.

When I was twenty-five, I started the Sphinx Organization, a nonprofit dedicated to the development of African American and Latinx classical musicians. Today the Sphinx is quickly approaching its twenty-second anniversary and has an annual budget of $5 million. Sphinx has been my life's true creative work, and it started as a spark—something that I saw needed changing. The opportunity to express my creativity through music is something I was hoping to create for others. Achieving that goal required me to put in some hard work.

As an undergraduate transfer student at the University of Michigan, I felt aimless and incomplete. The great classics, while timeless, were no longer inspiring in me that flood of emotion I had first felt. The music of my mother's house felt far away. So I began to seek out new music to fill my practice room with, hoping that I'd get that first feeling back again. I realized eventually that the key thing to capitalize upon was that search for something different, something that would bring a sense of connection and purpose.

It was then, while at lessons with my violin professor, that I discovered William Grant Still, a prolific African American composer. He wrote volumes of choral and orchestral works: works for violin, harp, and other stringed instruments—even a full opera and a string quartet! As I dove deeper into this genius's body of work, I eagerly consumed every bar of music, every chord progression, every movement. Stunned by this discovery, I found it inconceivable that I, a young biracial boy from Manhattan who'd been taking violin lessons since he was five, had never heard of this composer before.

Inspired by Still, I began to seek out black composers and musicians. In my whole life playing the violin, I had never known that there *were* any black classical composers—let alone anyone who had written volumes and volumes of works. It was as if scales had fallen

from my eyes, so to speak. Why hadn't I heard of Joseph Boulogne St. Georges, Roque Cordero, David Baker, Florence Price? Or any other pioneering musicians of color?

Most of the work my orchestra performed was written by white men. When I looked at the orchestra and our conductor (and at our audiences), it was mostly white faces I saw. This environment reminded me that I was different—that despite my talent, I somehow didn't belong. But why did it have to be this way? Where were the people of color in the orchestra pit and in the crowd? It was as if I had been missing a connection—and suddenly, through the music of Still, I had found it.

For my undergraduate recital, I put together the first all-black student quartet at the University of Michigan. We played a varied repertoire, including Still and other composers of color and even music from Mariah Carey, Boys II Men, and En Vogue. It was a fresh and vibrant experience for me as a musician—and as a person. Although we were only a small handful of musicians playing a single recital, that experience changed the course of my life. I wanted other underrepresented musicians to have this experience. To see others like me thrive like I had. I wanted orchestras that looked like the cities they played in. Orchestras that comprised musicians from all walks of life, that were as diverse as the music they played. Putting together this recital provided me a feeling of fulfilment I hadn't had since my days with Mr. Graffman.

That year—1996—I started Concert Competitions and Musical Development, Inc., the nonprofit that was to become the Sphinx Organization. As a competitive organization, Sphinx was meant to motivate young musicians of color to excellence through an annual concert competition. That was just the start of the program, however; the other purpose was exposure: Sphinx would give these young artists the opportunity to play with major orchestras, sharing their talent with the world. The experience would also make them better musicians, helping them get into some of the best programs. And perhaps most important, they'd get to meet other

young musicians of color. From the start, these young artists would know that they weren't alone.

Creating this impact required more than passion and music; there were material resources we had to secure. We needed instruments, rehearsal halls, and performance spaces. And for that, we needed funding. Like all artists, we had to work to convince the world of our worth.

With any nonprofit venture, fund-raising never ends. You might have the greatest idea in the world to address the greatest need in society, but if there is no sustainable funding mechanism, it will inevitably fail. I learned this from experience—as the seven other nonprofits I started prior to Sphinx failed due to poor funding. From Sphinx's inception, I made fund-raising a priority.

When you are initially building an organization, you have to fight to pull funds from wherever you can. When I launched Sphinx as a student, I would spend late nights at the computer lab printing out as many sheets as I was allowed through my student account. I would spend late nights at the copy shop key-lining our program ads, pasting each one up myself and lining it up with a ruler because we didn't have the money for a designer. You have to look at literally every single cost item you have and see whether there is any way to get someone to provide it to you gratis. You have to build your own network of fund-raisers. On reflection, I know that I never would have had the stamina or commitment to engage persistently on all of these fronts unless the underlying motivation was all-consuming. And it was. Sphinx's mission was my personal mission. I felt compelled to make a difference no matter what. Sphinx was my calling.

While preparing for my upcoming undergraduate recital, I received an interesting envelope in the mail. I was getting a lot of rejection letters at that point in response to my fund-raising requests for the Sphinx Competition. The envelope was meant for a half-size letter—almost like an invitation. On the back, it read "James Wolfensohn, World Bank," at which I grinned ruefully. I thought

to myself, *They don't even have enough money at the World Bank to send a rejection in a full-sized envelope.* I opened it roughly, expecting yet another disappointment.

As I pulled out the small letter, what I read stunned me. *Enclosed please find my one-time contribution in the amount of $10,000 to the Sphinx Competition. I wish you all the best in your endeavors.* I couldn't believe it. I read the letter twice, three times, and yet it was still true. It was surreal. I don't think I'd ever actually seen a $10,000 check before.

With this contribution, I knew in my heart that Sphinx was unlike my other endeavors—I knew I would change the world with it. Thanks to this donation, we soon began to receive generous funding from other organizations across the country, including a grant from the University of Michigan and donations from the Ford Motor Company. With that, I cobbled together the beginnings of what was to be the inaugural Sphinx Competition to take place in the late winter of 1998.

Over the years, Sphinx evolved. We began to show that we could muster the resources to help fulfill the dreams of so many aspiring black and Latinx musicians. We attracted young musicians of the highest caliber who were from diverse cultural backgrounds. Through our competitions and scholarships, we were reaching out and changing these young musicians' lives every day.

The reality was that, despite all these successes, we were still on shaky financial footing. I knew that the support of our initial donor base could falter at any time. Sphinx required breadth and diversity to increase its revenue streams. To get us to the next level, we had to secure a major six-figure partnership. There was only one place to get this kind of revenue: we needed a corporate partner.

Corporations demand personal cultivation. It was important to have both a detailed, targeted approach to attract specific corporations and foundations *and* a shotgun approach to reach a wider audience.

One of our key targeted partners was Texaco, which has a long-running history of support for the arts—specifically to the

Metropolitan Opera. Their support for national broadcasts and other musical endeavors boded well for our potential partnership.

It was on a slightly gray day in December of 1999 that I arrived at the Texaco headquarters, my Sphinx presentation firmly in hand. After checking in with the receptionist, I sat in a lobby that seemed to me to have been designed for giants. As I sat in this foreboding foyer in my stuffy suit, mentally preparing for my presentation, I felt the butterflies. This meeting was essential to winning the partnership we needed. In fact, I had prepared more for this than I had for my undergraduate recital.

After what seemed like an eternity, I was taken upstairs to a featureless boardroom and introduced to four or five cold faces. I began what I thought was a very well-planned presentation. I was asking for $150,000 per year for three years—a total of $450,000. Five minutes into my presentation, those cold faces began to pepper me with questions.

Although I had prepared as meticulously as possible, I simply did not have the experience necessary for a meeting with a roomful of top-level executives. In the end, I articulated our need, I held my ground, and I even presented myself well. But my request was met with silence.

A couple of weeks later, I received a call from Texaco's representative, regretfully informing me that they could not approve our proposal. They had decided to approve a smaller grant, however: $100,000 a year for three years. Three hundred thousand dollars! This represented the largest grant in Sphinx's history—and the stamp of approval of one of the most respected arts funders in the country.

Nearly twenty years later, Sphinx is transforming lives throughout the world. Thanks to the funding from all our donors, we place violins in the hands of hundreds of young people in Detroit, Flint, and cities like those across the world. We share the talents of Sphinx artists through our Sphinx Symphony broadcast, which has an audience of more than two million. Our premiere ensembles, Catalyst Quartet and Sphinx Virtuosi, have reached more

than one hundred thousand through their national tours. We've created educational residencies in South Africa, Belgium, and the United Kingdom, allowing us to connect musicians of color across national boundaries.

I could not be prouder of Sphinx. The organization's prestige has grown far beyond just me. In the beginning, it was my creative vehicle. Now it is an avenue through which hundreds of artists channel their talents, give back to their communities, and realize their dreams. Our alumni make up a familial circle, a connection I could only have dreamt of as a young undergraduate student at the University of Michigan.

As Sphinx plots its work for the next two decades, I reflect back on my early vision of the organization and how that simple recital of five musicians could spark a change for generations of artists. Today, the Sphinx Organization is no longer just me and my colleagues; the organization's faculty includes some of the most revered icons in our field. But most important is the way we have affected the lives of kids who look like me and share the same dream of music I had. Sitting at the intersection of social justice and the arts, Sphinx continues to fulfill a stark need through empowerment and commitment to excellence. My intent is for this book to help serve as a tool and a resource for all struggling artists who are striving to transform their passions into financially fulfilling careers.

Without Sphinx, I don't think I'd be where I am today, a MacArthur Award fellow, a member of the Obama National Arts Policy Committee, and President Obama's first appointee to the National Council for the Arts. But getting here wasn't easy. It took hard work and the trust of those who helped Sphinx grow and evolve. The organization wouldn't be as successful as it is now if not for my early mentors, the members of Sphinx's board of directors, and so many others who believed in its mission. Every person in the Sphinx Organization has poured the entirety of themselves into its success.

I hustled every day to get to where I am now. My determination to build an idea into an organization, to seek out donors to fund that organization, and to convince others to help make my dream a reality is not unlike the drive I needed to practice the violin for hours a day. And somehow I don't think a reel-to-reel recording of me practicing would fool anyone into giving me the opportunity to run such an organization. This tenacity is what has made Sphinx the foremost arts organization dedicated to youth development and diversity in classical music.

With Sphinx, I turned my personal art into a sustainable business. And it's turned out to be one of the most rewarding choices I've ever made. Not only is there the financial stability that comes along with this process, but, much more importantly, the artistic connections and overall breadth of human impact that I was able to have provide the life fulfillment that many artists seek on a daily basis.

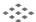

Artists are not taught to be businesspeople. Having served as dean at the University of Michigan's School of Music, Theatre & Dance, among other opportunities, helped paved the way for me to enter the teaching realm. Now, as professor of arts leadership and entrepreneurship, through my Creative Entrepreneurship course, I guide my students through the world of entrepreneurship in the arts. I find, however, that many artists think *entrepreneurship* is a dirty word. They see it as either a diminishment of their artistic endeavors or something that is at best irrelevant. They don't want to think about their art as a product to be valued but as a wholly unique thing that stands the test of time. To me, that seems misguided. Students in the arts are taught to think of their art as pure or sacred. As a result, they sometimes lack basic fundamental skills in making their art sustainable and sustaining. This lack of skills can translate into a fear of the unknown and—even worse—a fear of failure. That fear can lead to a paralysis.

Some of this comes more as a consequence of faulty assumptions, which in turn can form themselves due to outdated or incomplete perceptions of success and how it comes about. Art for art's sake was never actually viable nor true. From Oscar Wilde to Frederick Chopin, art has been a vehicle for expressing views, narrating history, and ultimately for connecting with others on a human level. Wilde was a poet but also a playwright and a journalist: he found a plethora of avenues through which to profess his view on life. Chopin was not only a composer or a pianist. His "Revolutionary Etude" is not only a study for pianists: it is a musical narrative on the bombardment of his homeland. Artists are people who journey on a quest to find their mission and share it with others. Successful ones, one way or another, build an enterprise around it.

Success rarely emerges on its own. It is often the follow-up of failure, which is rarely easy but absolutely essential. I've dealt with plenty of it. Before I started Sphinx, I had a handful of nonprofits, literary magazines, and other organizations that just never got off the ground. But if you are afraid of trying and failing, you'll never succeed. Resilience in the face of failure is what the hustle is all about.

Here is where artists have the upper hand over traditional entrepreneurs—artists thrive on failure. They take criticism every day in their rehearsal halls, studios, and work spaces. And when they fail, they learn to do it better for the next concert or gallery show. Good artists are experts at taking criticism and growing from experience. In fact, as artists, we do not define failure as such, but rather interpret it as an inseparable part of the process.

We're accustomed to associating the word *entrepreneur* with successful names like Zuckerberg, Musk, and Bezos. We think about entrepreneurship as something locked up in the Bay area, a thing that only "tech bros" would understand. Tech bros, however, do not hold a monopoly on entrepreneurship. As a matter of fact, some of the best entrepreneurs are artists—some of whom you know and admire.

These successful artists exhibit the same behavior as the tech giants featured in *Wired* or *Gizmodo*. Their tenacity, drive, and conviction have raised them to the highest levels of our cultural consciousness. For me, capitalizing on that fascination has been pivotally important. I tell my students to tap into that fascination, question and understand how exactly these guys got there. What was their secret recipe? What was the key to their success? How did they get to where they are? Is there a formula for this success? In many ways, this book tells stories as divergent as a spider web, but the common threads you will find woven among them illuminate a path that connects the creativity in all of us. Their stories are our stories. Their questions are our questions. Their dreams are similar to yours and mine. But what truly separates dreamers from doers? And is there a difference between doers and legends?

In order to find out, I identified thirteen individuals and interviewed the eleven who are currently living who I think exemplify the term *creative entrepreneur*. I listened to these individuals' stories and studied how they succeeded in the face of adversity. What I learned I've shared here with you in this book. These are heroes of mine—and hopefully yours soon as well. Some things you might read may be very much as you might expect. Many details may surprise you, and I truly hope they do. My wish for you is that you find enough that will resonate but even more that may awaken something new inside you. A new wave of inspiration. A desire to challenge yourself, the courage to keep searching. A different way to see yourself as an architect of your life's mission, an engineer of your own sense of purpose.

From every genre, discipline, and walk of life, these thirteen artists have surpassed others in their field. They know the hardship of the hustle but also the warm glow of greatness. In speaking with these luminaries, I learned that they are exceptional at three specific things:

- Ideation
- Organization
- Communication

To the thirteen artists in this book, progress isn't fueled just by inspiration. It's work—and hard work at that. It's work structured to enable them to achieve a goal: doing more of what they love and being unafraid to continually reinvent themselves to stay relevant.

Artists are constantly struggling with inspiration. Where do you get it? *How* do you get it? When inspiration strikes, the artist often turns it into a piece of work in their medium. But how can they be inspired to create without limit? Creative entrepreneurs know that inspiration is only a single part of their job. Creative entrepreneurs produce ideation—that is, they're idea machines, articulating their ideas in a way others can understand. Every day they come up with new ideas because they know that if they don't, someone else will come up with that idea instead. The creative entrepreneur seeks inspiration from everything, and they have a structure to get inspired.

They also know that creativity thrives on constraint and truly flourishes with organization. They know the ideas that come pouring out of them are not all good ideas. Their best ideas are simple and concise. They can take these best ideas and turn them into actionable plans. When they focus on a plan, they bring to it the same fervor they bring to practicing their craft. Everything that surrounds them reminds them of their art and passion, down to the exact specifications and decorations of their workspaces. For them, a portfolio isn't just a collection of their work. They live and breathe their portfolio lives, curating different ventures and expanding their knowledge daily.

And they are convincing. Creative entrepreneurs know they can't do it alone. Communication is their best tool to make their ventures a success. They can fit their communication style to their audience—conveying both their organizational goals and their artistic passions in a conversation, e-mail, or grant proposal. While most artists struggle to communicate the point of their work, creative entrepreneurs can convey their ideas succinctly and inspiringly.

These skillsets are not the only necessity. You still need talent and resilience—the mainstays of every artist's personality—and luck. As an artist, you might not necessarily want to be your own manager, but you need to know *how* to manage. Creative entrepreneurs have goals. The frameworks they build around themselves through ideation, organization, and communication not only make them better artists but create new opportunities for them to make art again and again. This process moves their art forward. An entrepreneur has no time to be paralyzed by artistic doubt.

No matter what the discipline, the arts field is competitive. No one goes into the arts because they think it'll be easy. Whether they're auditioning for a spot in an orchestra or writing pitches to donors, they do what they do because they love it. The jobs these artists seek are incredibly competitive—often with hundreds or thousands of applicants for only a handful of positions. You can practice hard, do your research on an organization, present yourself well at an interview or audition, and still not get the gig.

With the lessons you'll learn from these thirteen individuals, however, you'll have a distinct advantage over other artists who don't know the value of an entrepreneurial spirit. You'll have more ideas about where to take your art. You'll be able to put yourself in situations that position you for success. And you'll be able to convince the people you need to win over when you get there.

There's an age-old joke: "How do you get to Carnegie Hall?" The answer, of course, is practice, practice, practice. I'm glad I practiced. Not only did I eventually get to Carnegie Hall, I was able to bring dozens of deserving artists I care about to perform there. I got there through a combination of grit, creativity, and luck, practicing my proverbial instrument through entrepreneurship, each and every day, without fail. With your own talent, skills, and determination, you can get where you are seeking to go.

William Shakespeare

# William Shakespeare

## *The Upstart*

The wooden cart rattles against the cobblestones as the travelers pull into town. In the town square, their wagon shakes to a stop. Amid the shouts for fish and produce, these oddly dressed rovers pull out lavish silks, fake beards, lutes, and powdered makeup. Before long a crowd has gathered around their cart—first curious, then captivated. A troubadour emerges from the cart and begins a song. The actors begin to weave a tale of triumph, of tragedy, of whatever they had rehearsed the day before. The audience watches as the tale comes to a close after dusk. One young boy in the crowd stands transfixed.

It is England in the 1570s, and a young William Shakespeare can't take his eyes off the spectacle.

Shakespeare's beginnings were humble. He was raised in Stratford-Upon-Avon, a small village northwest of London. Due to its location on the River Avon, the village was a prime thoroughfare for traders but not a place one would dally for too long. Shakespeare was not born into a noble line nor was his family familiar with any nobility. He had only a typical education of the time and was not considered by any of his acquaintances to be a genius.

But there was one thing that set him apart: his love for performance.

In his time, theater wasn't appreciated as the high cultural experience that it is often viewed as today. There were times when fear of plague kept audiences at home and away from large groups. Puritanical pushback against the depravity of the theater

affected the public's perception of the art form. In addition, the recent Reformation, an heirless queen, and threats of invasion from Scotland, France, and Spain left many inhabitants of England culturally uneasy. There were a million reasons to keep away from the theater.

This England, however, was primed for the Bard. Not only did Shakespeare rise to literary sainthood, he contributed to unifying a fractured country. In all things, Shakespeare was simply an entrepreneur. All he wanted was to keep working.

In order to understand Shakespeare and the importance of his clever networking in the London theatrical scene, a little background on England during his life is needed.

Brick-and-mortar theaters were only just beginning to pop up. A loophole in the Act for the Punishment of Rogues, Vagabonds, and Sturdy Beggars allowed traveling players to create performance venues—provided that they obtained sponsorship from a member of the aristocracy.

These playing companies usually comprised ten or so men who also sometimes performed household duties for the lord who sponsored them. Roles were played only by men and young boys, as to have women on stage was considered lewd. The actors would play for the pleasure of their noble sponsors—a relationship that could lead to tight restrictions on content and style.

One of these companies was Leicester's Men. Sponsored by the Earl of Leicester, the company was led by James Burbage, a man with business acumen ahead of his time. With this company, Burbage founded the Theatre in Shoreditch, the first for-profit commercial theater in England, which was later rebuilt—in the most literal sense—as Shakespeare's Globe.

At the time, members of playing companies would receive payment for command performances from the lords who sponsored them. James Burbage, however, was unhappy with the restrictions the aristocracy put on artists. In order to break the chains of the lords, he ingratiated himself to his sponsor, the Earl of Leicester, and

they became good friends. On his deathbed, the earl granted the company legal protection to perform what they wished, with the stipulation that all support would be derived from the profits from ticket sales. This made it so that each member got a cut of the profits for any given performance. If a performance was not successful, a company member's salary would dwindle. This incentivized everyone to work harder and create better work. Leicester's Men was the first company in London to adapt this revolutionary model.

When Shakespeare began his career, Burbage's influence on the company system shaped the young Bard's approach to collaboration. It was clear to Shakespeare that if he didn't have a good network of collaborators, he couldn't be successful in the industry. When Burbage died, he left the Theatre in Shoreditch to his son, Richard Burbage, a player in Shakespeare's company. The landlord disputed the claim, however, preventing the young Burbage from taking possession of the theater. So Burbage, Shakespeare, and other members of the company took control of it in the middle of the night. Piece by piece, board by board, the company disassembled the theater and shipped it across the Thames. Those parts were reassembled into what we now know as the Globe.

One would think that a genius writer wouldn't be around for the strike of a full theater. But there was Shakespeare, crowbar in hand. Anything that needed to be done for his compatriots, he did—and gladly. Like all entrepreneurs, he knew that he needed to continually build up his value within the community he wanted to lead.

Our timeline of Shakespeare's life is shaky. We know that sometime between 1585 and 1592 he left Stratford for London. Once there, he began to build his network of both actors and aristocracy. When he first arrived, he was hardly the lofty playwright we know today. In fact, he would do nearly anything in the theater. Need

someone to read a role? Will was on it. Want someone to wrangle the actors? Will could do it. Have a terrible play that needs a few extra good lines? Will was at your service. He quickly became a mainstay in the London theater scene through what was almost a textbook example of early entrepreneurship: he repeatedly demonstrated his value to his community.

In addition to our young Bard's multiple theatrical talents, he was also engaged in one of the rare forms of publishing that existed at the time: poetry. While we remember Shakespeare for his plays, it was his poetry that attracted the attention of the aristocracy of his day. His poems spread almost like chain letters: Shakespeare would write a sonnet—either about a specific subject or a mysterious figure—and then send it into circulation among the best-known lords and ladies. This was one of the ways Shakespeare endeared himself to the upper crust of London society—and how he attracted the interest of potential benefactors and sponsors. Through his poetry, Shakespeare became a household name among the gentry, who would eagerly attend his performances at the Globe.

While Shakespeare was involved with many theatrical endeavors, there was one cohort of which he was an essential member: the Lord Chamberlain's Men. This group was where he met such theatrical contemporaries as Richard Burbage (son of James), William Kemp, and John Hemmings—all accomplished, prominent actors. Like Leicester's Men before them, the Lord Chamberlain's Men had an incentive-based system: if a show did well, all the shareholders reaped the benefits. And while many members of the company made a decent living (Shakespeare went on to buy the second-largest house in Stratford), economic success was not the only object. These men also found their joy in making something new.

At the time, theater was entertainment, not literature. You couldn't buy a copy of Shakespeare's latest play at a bookstore. Plays were *happenings*, things meant to be experienced firsthand. What we think of as dialogue between two characters was rarely etched out onto one piece of paper. In fact, each actor received a piece

of parchment that only had a couple of things: their cue line, the line they had to speak, and the line immediately after theirs. It was not uncommon for a performer not to receive their text until the morning of an evening performance. While we have little evidence of their rehearsal practices, one only has to look at the amount of text in a play like *King Lear* to marvel at the mental capacity of these performers.

And this was how most of Shakespeare's theatrical career went on. He would write the play, work with his company to produce it, assign the roles, and put on a show. Shakespeare was a pillar of the Lord Chamberlain's Men. His passion for creating was infectious, and it spread to all his colleagues. This intensity made their performances compelling to audiences from every social sphere.

This passion, however, was not shared by all of London. Shakespeare made many enemies in his time as the writer-in-residence for the Lord Chamberlain's Men, and unfortunately, some of those enemies were those who held the most sway in the Royal Court. Robert Greene, a contemporary playwright of Shakespeare's, was offended by his brusque style, referring to him as an "Upstart Crow." Ben Jonson, another playwright, said Shakespeare's writings were "little Latin, and less Greek." Johnson and Greene were university-educated playwrights, wedded to Aristotle's theatrical ideals—that is, to Aristotle's rules. And Shakespeare was breaking every single one of them.

One example of Shakespeare's maverick nature was his tendency to mix genres. One only needs to look at *As You Like It* to see this in action. While act I is mostly a tragedy—our heroine, Rosalind, is banished from the court due to her uncle's insecurities—acts II through V are a pastoral comedy including a roving band of musicians, a bawdy shepherdess, a melancholy clown, and the six couples joined in marriage by the last scene.

*As You Like It* was one of Shakespeare's most popular plays. It was a definitive crowd-pleaser, and Shakespeare knew it. He wrote *As You Like It* for his audience—the titular *You* being his ticket

buyers. Shakespeare's work *had* to be as eclectic as it was in order to appeal to the diverse audiences of the Globe. In order to stay relevant, he needed to appeal to the highbrow aristocracy to spread his reputation and to all classes to fill his theater. Through his style, Shakespeare united these two social classes, making the Globe theater a democratic place where anyone could enjoy whatever was happening on stage. Just as he helped his colleagues by filling in for whatever they lacked, he now helped by writing crowd-pleasers that kept his friends employed.

What made his work so engaging for his audiences was that there was something for everyone. While other playwrights were engaged in a variety of innovations in theater, Shakespeare would add tragic elements to his comedies to keep his audiences guessing. Likewise, his tragedies contained elements of comedy.

This is perhaps nowhere more evident than the Porter's comic speech in *Macbeth*—a drunken slapstick scene that comes immediately after Macbeth murders King Duncan. This tendency to mix styles is distinctly modern—and was the source of complaint from some of the educated elites.

But his audiences loved it. One reason Shakespeare wrote in this way was that he knew he needed to grab his audience's attention and hold it despite the distractions surrounding the playhouse, such as food vendors hawking their wares and prostitutes offering their own services. Shakespeare knew that if the action on stage wasn't more interesting than what was happening in the audience, he lost.

The Globe was consistently filled to capacity (except perhaps for when it was closed due to the plague). In order to meet demand, Shakespeare had to grind out play after play—often with little to no time in between performances. And because of the shareholder model his company ran on, he had to keep creating new work to keep himself in the black. A case of writer's block for Shakespeare might mean a missed rent payment or a hungry belly. He couldn't afford to wait to be inspired. Often the process of ideation requires an internal motivation rather than just inspiration from others. In

order to keep the play machine running, Shakespeare looked to other writers for his material. While we think of his work as revolutionary, most of his plots were pulled directly from other sources including the myths of antiquity, French and Italian writers, folk tales, and chronicle histories. Greek writers such as Plutarch and Ovid provided basic stories, which Shakespeare molded to fit the times and his own poetic style.

However, one of the most important fonts of inspiration for the Bard was Raphael Holinshed, an essayist and historian. His book, the *Chronicles of England, Scotland, and Ireland*, probably sat on Shakespeare's desk immediately next to his quill. Holinshed's writing directly inspired what was one of Shakespeare's greatest innovations: the English historical play.

Look at any collection of Shakespeare's work and you'll see his plays are divided usually into three groups: tragedies, comedies, and histories. While the tragedies and comedies were common at the time as well as using historical materials, English historical plays were an invention of Shakespeare's. He would dust off his copy of Holinshed's book and write a play based on what he found therein. These plays took the intricate and complex tapestry of British history and served it up in a digestible and entertaining way.

These histories were a massive hit. As I mentioned before, England was experiencing a bit of a cultural crisis. Facing constant external pressure from France and political issues at home, Brits were questioning their own story. What did it mean to be British? In Shakespeare's histories, audiences witnessed a pageantry of their ancestors paraded across the stage. They saw the battle of Agincourt and watched brave Hal rise up from mediocrity to take his place as King Henry V. They saw how Richard III's conniving spirit led to his downfall. In these plays, audiences found cultural touchstones that anchored their own English identities.

In 1603, thanks to Shakespeare, the Lord Chamberlain's Men gained a new sponsor: King James I of England. Thereafter, they were known as the King's Men.

Shakespeare found incredible joy in his work. Writing poured out of him, and he was grateful for it. In his life, he wrote thirty-seven plays, one hundred and fifty-four sonnets, and five narrative poems. He coined more than 1,700 words—many of which we still use today.

However, his work might have been lost to history if not for one particularly wise and entrepreneurial thing he did. While he was a success during his life, the impact he'd have on history wasn't immediately clear. In fact, I might not even be writing this chapter if it weren't for his greatest accomplishment: his incredible network of friends.

When Shakespeare passed in 1616, there was no definitive compilation of his work. There were scratches of lines here and there including some published quartos, and there were actors who knew his plays because they had their lines memorized. The plays were still being performed, but the people who knew the lines were beginning to grow old. And there were dubious versions of his plays. Performers would claim to have the entirety of one of his plays memorized, offering the words in their heads to the highest bidder.

As this practice grew more and more popular, members of the King's Men banded together to put a stop to these counterfeits. Pulling together promptbooks and author's "foul papers" and "fair papers" (revised and copied texts) along with scraps of roles they'd had and lines they'd memorized, Henry Condell and John Heminges prepared the First Folio, the definitive collection of Shakespeare's plays.

Shakespeare spent his life cultivating the camaraderie and trust of his partners. He was not just a writer but a collaborator. He wore multiple hats for the company, never shirking work or responsibility. In his time, he wrote entertainment, but because of the relationships he cultivated, we read him today as literature. His collaborative spirit is what made him the greatest writer in the English language.

Shakespeare's entrepreneurship is unquestionable. What we know about him proves that he had the endurance, flexibility, and passion to make it in the arts. Creative entrepreneurs should take a few lessons from his life.

## ARTIST-ENTREPRENEUR TAKEAWAYS

Be persistent. The Bard never gave up; he was a bulldog. When the show looked like it might not go on, he *made* it go on. What other genius ever disassembled a theater piece by piece? It was certainly dirty work and definitely not glamorous. But he knew it had to be done.

Build partnerships with a broad community. While the King's Men owe a lot of their success to Shakespeare, he owes his legacy to the relationships he built with his company members. His intimate knowledge of his audience also meant he knew how to work with people from diverse backgrounds. And his poetry circulated among the nobles could be seen as an ancestor to modern-day fund-raising campaigns.

Be joyful; be daring. Shakespeare's art drove him to question the world and to lift up the common man. He was constantly breaking rules, trying new things, and creating new experiences. He persevered in the face of failure. His reason for doing all of this was simple: he did it because he loved it. The Bard of Avon, William Shakespeare, had fire in his eyes and hunger in his belly. He might not have set out to change the world, but through his persistence and his willingness to network, he did.

*Chapter based on an interview with Linda Gregerson, chancellor of the Academy of American Poets, fellow of the American Academy of Arts and Letters, professor of English and creative writing, University of Michigan*

Wolfgang Amadeus Mozart

# Wolfgang Amadeus Mozart

## *"Loved by God"*

In 1763, Wolfgang Amadeus Mozart was a sideshow before he was a sensation. From the time he was only seven years old and until he was ten, Mozart and his family traveled from one European court to another, with Mozart and his sister, called Maria Anna and nicknamed Nannerl—also a musical prodigy—playing for kings and dukes. Mozart, of course, was the main attraction. He dazzled the lords and ladies with his fine violin skills and genteel manners. While his playing was indeed good, it was his age that made him a real attraction for the aristocracy. Amadeus means "loved by God" in Latin, and for anyone who saw Mozart perform, it was hard to deny God worked in that child.

Mozart's father, Leopold, was a talented and widely respected music teacher who some consider one of the greatest pedagogues of his age, and Mozart's own skill with the violin bordered on virtuosity. After a court concerto, Mozart would be awarded a small but extravagant gift by the noble who had sponsored the evening. These trinkets were always beautiful to behold: golden eggs filled with diamonds or extravagant bejeweled necklaces. Upon receiving the gift, the young boy would bow his head in thanks. As he piled into the caravan that would carry him off to his next engagement, he would pass the present off to his father, who would then sell it to feed the family. And then they'd be off to the next courtier who wanted to hear the preternaturally talented young violinist.

Leopold knew the life of a musician was hard. He had already made his name in the business as a music teacher, but he craved more

for his children, Wolfgang and Maria, whom he trained rigorously. Drills and practices would run for hours until they were perfect.

At the time, the Mozarts were playing solely to the upper crust. Leopold knew that the wealthy would pay handsomely to see a child prodigy make the violin sing, so he shaped Wolfgang into one of history's most famous young musicians. He worked hard to turn his boy into the spectacle he became. For Leopold, Wolfgang was his livelihood and his greatest work to date. In this way, Mozart's father may have been the first entrepreneur the young composer ever knew.

While Mozart's innate talent was undeniable, it was his father's demanding training that unlocked his true genius. His impressionable age also kept him from acquiring the psychological inhibitions that hamstring many musicians. When he played for these aristocrats, he had no idea that what he was doing was considered difficult. If he made a mistake, he just went on playing without missing a beat. For him this was play, not work. He didn't have the fear of failure that paralyzes many artists; my feeling is that this was because Mozart was simply too young to know that fear. Precocity was his advantage.

As the young violinist grew, his father secured him a position playing violin for Count Hieronymus von Colloredo, the Prince-Archbishop of Salzburg. In the eighteenth century, musicians in Europe were servants to a hierarchical power structure. Music was an arms race, with each European country or territory constantly trying to gain more cultural firepower than its neighbors. Art was an ego-driven contest for the rich and powerful, with artists caught in the middle.

A musician was obliged to play pieces that celebrated the power of the aristocrat who sponsored him. The bigger the orchestra an aristocrat had, the more important they were considered to be. Artists vied for the patronage of European royalty, and every artist understood the importance of these appointments. Making your way through the politics of these court orchestras was no easy task, however. The coveted positions of first and second chair were distributed by seniority, reserved for old-guard members who had put in their

time—and these old musicians had considerable sway over the nobles who sponsored their art and therefore over the general direction of the orchestra. Newcomers had to prove themselves and be patient.

It was a musician-eat-musician world where only those who looked out for themselves survived. And the court where Mozart was working was no less nepotistic, tiered, and toxic than any other.

In the court orchestra of Salzburg, Mozart played second fiddle to a musician whose name has been lost to history. At first, Mozart was diligent in his position. He played by the rules and grew to be favored by the count. But as time went on, he became frustrated at the lack of opportunity to put his talent to good use. His impatience with the older members of the orchestra began to mount, and he began to disdain the artistic direction of Count von Colloredo. He began to miss rehearsals and performances. Eventually he petitioned the count to allow him one last tour of Europe on his own. If Mozart had learned nothing else from his entrepreneurial father, he'd gathered that exposure would always sustain him.

Disillusioned with the court system, Mozart set out on a tour across the continent. He spent this time as a kind of sabbatical and took the time to study other musicians and their work. Hungry for new ideas, new expressions, and new movements, he listened to the best orchestras France and Italy had to offer.

After his tour, Mozart decided to completely reject the court system . . . by forcing the courts to reject him. In 1781, his insubordinate behavior got him kicked out of the Count of Salzburg's orchestra—one of the count's men literally kicked him in the backside on his way out the door. Writing to his father, he said, "If they don't want me—that's fine by me. . . . In plain language this means that as far as I'm concerned, Salzburg no longer exists." Mozart was officially a free agent—at a time when an unmoored musician faced terrible economic instability.

His father was furious.

Leaving the court posed a lot of risks for Mozart, both to his finances and his reputation. Leopold knew this, and Mozart's absconding created much tension between father and son. But necessity is the mother of invention, and Mozart knew he had to think fast and push himself to create—his livelihood depended on it.

Mozart was twenty-five and without a job. The previous year, his opera *Idomeneo* had opened to critical success, from which he reaped some benefits—but ultimately no steady paycheck. As a matter of necessity, Mozart developed what author David Corbett refers to today as a "portfolio life"—meaning that his working life wasn't defined by just one activity.[1] He took on small jobs that allowed him to meet new people and patch together a living. From composing to performing to teaching, Mozart did it all and thereby kept his pockets full and his face visible. He loved his art, but he treated it like a business, creating as many revenue streams as he could.

His father, ashamed of his freelancing son, pleaded with him to return to Salzburg and beg to be restored to his position. But Mozart refused. He was in Vienna and wanted to make the best of his newfound independence. On the other hand, his bills still needed to be paid. Using the network he had spent his entire life building, Mozart began to meet the wealthy and well-to-do of Vienna.

Performance came naturally to Mozart; he'd been doing it since he was a boy. In Vienna, he'd play small solo piano or violin concertos to sold-out houses. On occasion, he'd get some musicians together and put on an impromptu performance; he became famous for these spontaneous events. During one such happening in Vienna, he engaged in a piano competition with famed pianist Muzio Clementi before the Emperor of Austria. Mozart's victory over Clementi brought him to the attention of a whole new network of benefactors. He wasn't only playing to the wealthy elite; now Mozart often played to middle-class crowds as well. He was expanding his audience to create a safety net of potential benefactors.

As music halls were not always available, Mozart took to booking his performances in nontraditional venues: rooms in restaurants and

apartment buildings—any place big enough for a piano and a music stand. Through these intimate performances, Mozart made part of his living. More importantly, he endeared himself to the common man—people he preferred immensely to his wealthy students.

Teaching was another way that he'd keep his pockets full. His patrons turned to him to shape their own children into musical prodigies. Mozart hated it. He wrote several letters to his father describing his frustration with teaching. While it was lucrative, he couldn't abide the coddling his pupils required, nor the obsequious brown-nosing their parents expected of him. Mozart continued to teach for most of his life, but it was never his greatest joy—just something he did for cash. In this respect he was unlike a number of other arts entrepreneurs throughout history who developed a real passion for passing on their knowledge.

Composing buoyed Mozart's spirits more than his purse. But with limited resources due to a lack of sponsorship, he had to compose smart. His operas were small ensemble pieces driven by interesting melodies and comic plots. Most notable of these was *The Marriage of Figaro*, a chamber opera with a cast of eleven and a scant chorus. In order to cut costs (and increase his profits) even further, Mozart himself directed part of the premiere production at the Burgtheater in 1786.

In the following years, Mozart again turned his attention to well-known composers in his quest to learn more. The reluctant teacher was an eager student. Mozart would endlessly play the manuscripts of Bach and Handel, which had been gifted to him by a wealthy diplomat. As he played these masterpieces, he would absorb, dissect, and analyze the phrases produced by these Baroque masters. These hours of play and iteration influenced one of Mozart's greatest masterpieces, an opera he'd compose later in his life, *The Magic Flute* (1791).

Mozart was not only enchanted by legendary composers from times past; many of his contemporaries caught his ear as well. In 1784, Mozart met Joseph Haydn, and the two quickly became

friends. They would often play together in Haydn's famous string quartets. Their time together left quite an impression on Mozart; he wrote six quartets for Haydn and his instrumentalists. For Mozart, music was a gift that he gave to those he adored.

While success in music seemed to follow Mozart everywhere, there was one important place he was failing: his finances. It is true that his portfolio life was returning dividends for him both artistically and monetarily, but he and his wife had expensive tastes. Rubbing elbows with the aristocracy had gotten them both used to an elevated lifestyle. And as happened to Shakespeare, the absence of copyright law was also affecting Mozart's revenue stream.

Mozart's borrowing habits certainly didn't help his financial situation. He would borrow from family members, patrons, and friends in order to feed himself and his family. But those debts loomed over him, and when his sources of borrowed cash dried up, so too would Mozart's cupboard. This was one huge risk of his freelancing, and he knew it. But instead of giving up, Mozart redoubled his efforts. This type of perseverance is critically important, especially during the challenging stages of any entrepreneurial life, whether they are self-inflicted or externally caused.

Mozart was a melody machine. Every day he was busy crafting new pieces, but his music had a life of its own—a life he couldn't control. If he played a piece at one of his intimate performances, there was nothing to stop someone in the audience from quickly jotting down the piece, arranging it for another instrument, and selling it on the street—with no profit for Mozart. These counterfeits were so widespread that Mozart was forced to strive constantly to create newer music that was better than what he had made before. While the competition of the "fakes" had to be addressed, it was Mozart's underlying love and passion for the music and his much more than ten thousand hours of invested expertise that enabled him to so consistently create these new works.

Mozart's music was ahead of its time. His influence on music so shaped our perceptions that it is hard to see from our modern perspective how revolutionary it truly was. Mozart completely changed the face of music including having originated the classical piano concerto almost single-handedly.

There couldn't have been a better time for Mozart to be creating all this new music. During his lifetime, Mozart witnessed revolutions in the United States and France. And while political revolutions were being fought abroad, a social revolution was happening in Vienna: music was no longer completely centralized in the power of the courts. It was expanding into the homes of the middle class, and our Wolfgang was part of the reason why. Like most visionaries, he was in touch with the spirit of his time.

Mozart's work was always written for the common man—the segment of his audience he appreciated the most. His unusual performance venues allowed him to open up ticket sales to the general public, so that music was no longer just for the wealthy elite. And these performances were usually more raucous and lively—perfect for the non-noble class. These audiences filled up the theaters for his small operas, which also featured something for the common man. While his contemporaries were writing epic operas about lords and ladies, Mozart focused on common, everyday characters to tell his stories. *The Marriage of Figaro* is one example of this. While Count Almaviva and Contessa Rosina are major characters, it's the count's servant Figaro and his wife, Susanna, also a servant, who move the comic action of the opera forward. Audiences ate up their hijinks and were enraptured by their story.

Well, not all members of the audience. It was true that while Mozart was a favorite of the average gentleman, some others were jealous of his talent. Like most geniuses, he was not well appreciated by all of his peers. At the premiere of *Figaro*, hired hecklers interrupted the action on stage. The newspaper *Wiener Realzeitung* commented on the scene:

[The performance] heard many a bravo from unbiased connoisseurs, but obstreperous louts in the uppermost story exerted their hired lungs with all their might to deafen singers and audience alike with their *St!* and *Pst*; and consequently, opinions were divided at the end of the piece.

Who hired these hecklers and why they did so remains a mystery. However, given the disdain Mozart had for those in the court and the contempt with which they in turn treated him, it's not hard to imagine that jealous court composers might have hired these ruffians. As we saw with Shakespeare, being a genius rarely endears you to your peers.

As Mozart grew older, the stress of his economic struggles contributed to a growing mental instability. In his early thirties, he commented to friends that he was experiencing "black thoughts," and some modern-day historians believe he may have had a bipolar disorder of some sort. Despite his troubles, however, Mozart never stopped working. It was during this time that he wrote *The Magic Flute*, one of his most popular operas.

In 1787, Mozart was appointed "chamber composer" by Emperor Joseph II—a boon, as his finances continued to dwindle. There was, of course, the underlying irony that this flew in the face of his long fight for freedom from aristocratic benefactors, but the practicality of day-to-day life had to take precedent. Unfortunately, this was a part-time gig—just a few dances to be composed for the emperor's annual royal balls. With a family to feed and a relentless need to keep composing, Mozart was becoming less and less stable.

Mozart died in 1791, at the early age of thirty-five. He left his wife, Constanze, with his enormous portfolio of work. Unfortunately, because of her late husband's outstanding debts, she had little power to sell his pieces, and most of what he left her was scavenged by his debtors.

In his short life, Mozart composed more than six hundred pieces. While he was alive, there were around 1,700 other working composers, many of whom have been forgotten. Yet Mozart, thanks to his genius and his persistence, is still with us today.

Some people choose to address problems according to the rules set in place by the system. They work tirelessly to conform to social mores, make the right meetings, and obey the rules. Others choose to disrupt the system altogether. Mozart was solidly in the latter category. From the age of ten, he was turning heads at every gathering he attended.

For Mozart, success meant the freedom to create what he loved—music.

## ARTIST-ENTREPRENEUR TAKEAWAYS

Lead a portfolio life. In order to thrive, Mozart expanded his revenue streams by accepting positions in all areas of music. He taught. He performed. He composed. Through these diverse activities, Mozart not only perfected his musical skills but also gained allies and patrons. His living portfolio not only helped his pocketbook but also expanded his circle of friends.

Create value. Remember, Mozart was a sideshow at first. But he yearned to be the star and he worked toward it. He pushed forward and he changed audience expectations so they wanted to hear what he wanted to write. By studying the great classics, he drew inspiration to create new styles of music to elevate his listeners and his audiences. Mozart crafted experiences.

Challenge the status quo. When Mozart set out to be a freelance musician without the support of a court, he took a huge risk. But he was determined to be successful and to get out from under the thumbs of the aristocracy that stifled his talent. Because of his status as an independent, Mozart was able to expand the appeal of his music to reach new audiences in a manner that placed him far ahead of his time. He truly blazed a trail that helped transform an entire art form.

*Chapter based on an interview with Mark Clague, associate dean for Academic and Student Affairs, associate professor of musicology and codirector of the American Music Institute, School of Music, Theatre & Dance, University of Michigan*

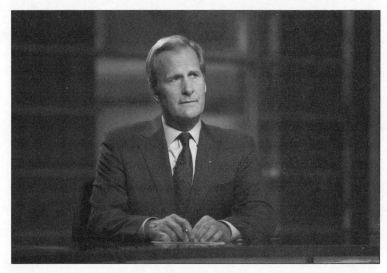

Jeff Daniels

# Jeff Daniels

## *The Hard Work*

It's 6:00 a.m. in Hollywood. Jeff Daniels is parking his car in the Sunset Gower Studios lot where he'll be shooting today. He's talking to himself. Under his breath, he speaks fragments of sentences—repeating words to himself every time he stutters. He tests out emphasis. He tries different intonations. He writes the words in the air and then erases them when they don't flow. Talking to yourself in public might make you look crazy, but Jeff is just practicing his lines for his first day on set for *The Newsroom*, Aaron Sorkin's HBO drama.

By six thirty, he's sitting in a circle with seven of his colleagues. Some of them have their scripts, but the wiser ones don't. Jeff's script is neatly tucked away. He doesn't need it.

Aaron takes a seat in the circle, and the cast begins to run their lines. Aaron gives a few notes—pick up the pace here, think about this when saying that—but largely stays quiet. To those who stumble on a word or a phrase, the writer shoots a look of disapproval. Jeff never stumbles. He's worked his whole life for this.

Jeff Daniels grew up in Chelsea, Michigan, below the thumb of the proverbial Michigan hand. He was always good at acting, but it was never something he loved—just something he enjoyed. Because he was good at it, he was in play after play as a kid: *Oliver*, *Fiddler on the Roof*, *Hello Dolly*. He also played basketball, mainly because of his height, and he was in the school choir, mainly because he could carry a tune. Jeff was good at a lot of things, but he didn't enjoy any of them as much as acting.

Throughout his career, Jeff always worked harder than the other guys. He believed that unless you let your ego get in the way, you can only get better at performing. When it was time, he went to Central Michigan University to study theater. While there, he got the chance to participate in Eastern Michigan University's Bicentennial Repertory program. There he met Marshall W. Mason, cofounder and artistic director of New York's Circle Repertory Company. Mason was impressed with Jeff and invited the nineteen-year-old kid back to New York to work on a script by Lanford Wilson, Circle's other cofounder. Little did Mason know that he was making the young actor's dreams come true.

You see, throughout his time at Central Michigan University, Jeff would skip class in the afternoon and sneak off to the local movie theater. One day he bought a ticket to *Dog Day Afternoon* and found himself transfixed by Al Pacino's portrayal of Sonny Wortzik. Jeff was so taken with this film that he saw it six times. He would watch from the back row as the bank robbery went to hostage situation to sideshow over the course of two hours. He had never understood before why he wanted to act, but he saw himself in Al Pacino, and he knew he wanted to be like him. And in Jeff's mind, the only way to do that was to get to New York.

Within a couple of years, Jeff was in an Off-Broadway production of one of Wilson's newest plays, *The Fifth of July*. The play was produced by Circle Repertory Company and directed by Mason. It was a small part, but Wilson had written it for Jeff, with encouragement from Mason.

After that, the show toured to L.A. before coming back to New York for its Broadway debut. Jeff was getting his first taste of being a working actor, and it was tough. The midwestern boy from Michigan found himself surrounded by talented elites from both coasts. At times, Jeff felt alienated from the New York theater community. While his peers called Juilliard their alma mater—or NYU or Yale School of Drama—Jeff would just mumble that he

had gone to CMU. When asked if that meant Carnegie Mellon, Jeff would sheepishly respond, "Central Michigan University."

This drama played out in almost every audition room he entered. Before an audition, Jeff would sit in the waiting room looking at ten other guys who had gone to better schools. At first he was intimidated, but like any other great actor, Jeff used his emotions to his advantage. Fueled by his insecurity, he worked hard and prepared—and landed the gigs.

Then came the day he landed the part of Flap Horton in *Terms of Endearment*—a breakout role. While Jeff had prepped for that audition for weeks, deep down he knew that getting the part came down to dumb luck. He was in the right place at the right time doing the right thing, and the door had opened for him.

Jeff had gotten lucky, but he knew he couldn't just sit around and wait by the phone hoping to be discovered. Like an athlete, he had to be ready to catch the ball when it was passed to him and take it into the end zone. He knew this role was an opportunity, and he was right: *Terms* was critically acclaimed. Nearly everyone in the ensemble was nominated for an Academy Award—everyone but Jeff. On Oscar night, he was sitting with a friend in his New York apartment watching the awards on TV. His friend leaned over to him and said, "Hey, Jeff, even the guy who combed your hair was nominated!"

But the lack of recognition didn't faze Jeff. It was about the work, and the work he did well. That was in 1983. Over the next ten years, Jeff worked constantly, taking roles in such diverse projects as Woody Allen's *The Purple Rose of Cairo* and the B-movie creature feature *Arachnophobia*. He had a family to feed, of course, which was a big motivator, but he also found himself most alive when he was performing. Acting was a drug for Jeff—better than drugs.

Project to project, Jeff honed his skills. He used each piece to stretch himself in a new way, to push himself to do something different. He eventually became a recognizable face, if not a household name. Mainly known for his dramatic work, he was on the

lookout for a challenge—which he got when *Dumb and Dumber* landed in his lap. Paired up with Jim Carrey, Jeff was to play a dim-witted dog groomer on a cross-country quest.

*Terms of Endearment* was Jeff's first critical success, but *Dumb and Dumber* was the box office blockbuster that made him a star. Jeff was now working constantly, making a new movie almost every year while continuing to live in his home in central Michigan. He had made the choice back in the eighties to raise his family in his home state, which gave him some respite from the Hollywood hustle and bustle.

But as the millennium approached, commuting to work in L.A. began to wear on him. He knew he had more to offer creatively, but he wasn't sure what that was. He began to think back on his time in the theater and how Marshall W. Mason had helped him land his first gig when he was a fresh-faced kid just arriving in New York. Could he do something similar for some young actor in Chelsea, Michigan? He wanted to somehow encourage future generations of theater professionals in central Michigan and pay it forward.

That was the seed that yielded the Purple Rose Theatre in 1991. He envisioned the Purple Rose as a laboratory for new works, not only for himself but for all Michiganders; a place where emerging artists and seasoned professionals could come together to learn and practice their craft and hone a uniquely midwestern theatrical voice. For the first ten years, the theater was located in a bus garage owned by Jeff's grandfather.

Jeff served as executive director of the Purple Rose, going off to Hollywood to shoot a film for half the year and then coming back to work a theater season for the other half. But as the company grew, Jeff found himself in Chelsea more often than in Hollywood. He began to branch out from acting and focused on creating theater in a more holistic way. He wrote plays, directed, taught classes, and engaged with his community. One of the pieces that he work-shopped at the Purple Rose was *Escanaba in da Moonlight*, a comedy about hunting culture in Michigan's upper peninsula. The piece

was so successful that in 2001 Jeff turned it into a movie, which he wrote, directed, and starred in. In many ways, Jeff had created the very place (the "school") that he felt he had missed out on.

His experience as a playwright changed the way Jeff saw acting. He began to see how playwriting informed acting and vice versa, and he eagerly embraced this personal creative renaissance. He spent most of the early 2000s growing the Purple Rose and eventually built a whole new space for the theater. In the Purple Rose, Jeff became a new artist who took as much pleasure in encouraging other artists to grow and learn as he did in a glowing *New York Times* review of his own work.

In 2005, Jeff found himself at a crossroads: he was fifty years old, and he was beginning to feel burned-out. His latest film, *The Squid and the Whale*, had been well received at Sundance, and praise had been heaped on him for his portrayal of Bernard Berkman, a writer navigating a midlife crisis and a divorce (a performance for which Jeff would eventually win a Golden Globe). He was also set to perform in the American premiere of *Blackbird* at the Manhattan Theater Club. Despite these successes, Jeff felt he'd reached his limit.

Over lunch with Jim Carrey one day, he expressed his exhaustion. Plays go late into the night, and movie sets require you to be up early in the morning. He was tired, he told Jim. He just wanted to give up, retire, and spend time with his wife and kids.

"But you can't," said Jim. "You're too good at this, Jeff. You've got to find a way to express yourself. You can't stop moving; you're like a shark."

While Jim had a point, Jeff nevertheless felt defeated and detached. He'd failed to renew his interest in theater, film, or performance in general. He felt ossified, and his productivity suffered.

But then in 2010, the Aaron Sorkin pilot *More as This Story Develops* came across Jeff's desk. The series revolved around Will McAvoy, a TV journalist who is fed up with the corporate control over his broadcast and is ready to quit the business—until his ex-girlfriend breezes back into his life as his new executive producer. *More as This Story Develops* eventually became the hit HBO show *The Newsroom*.

Jeff was enraptured by Sorkin's meticulously crafted script and hungry for the role of Will McAvoy. In so many ways, it matched how he felt. He knew he'd have to work hard for it—but fortunately, Jeff had been working hard his entire life. He had his agent set up a meeting with Sorkin.

Aaron thought Jeff was a fine actor but had misgivings about casting him in *The Newsroom*. Will needed to fly off the handle from time to time. The character needed someone who could get angry—righteously indignant, even. Sorkin wasn't convinced that Jeff would be able to bring the right energy to the role.

The two men met over breakfast in New York. Aaron was upfront with Jeff. "I'm just not sure you can get angry." Aaron said. "That's my only reservation."

Jeff heard this and cringed. But then he got it—this was an audition. Jeff went deep inside himself and connected with his anger, and within moments their civil conversation had transformed into an all-out altercation. Jeff banged on the table, raising his voice across from one of America's most respected television writers. He was showing Sorkin what he could do. Other patrons at the next table turned to see what the commotion was about.

By the end of the breakfast, he had the role and, in retrospect, Jeff thought that the bang on the table may just have gotten him the part. Just like he utilized his fear to practice harder than everyone else, Jeff used his anger to land this job. Entrepreneurs turn challenges into advantages.

Although *The Newsroom*'s first season received mixed reviews— some critics found the tone of the show smug and preachy—Jeff's

portrayal of Will McAvoy was universally acclaimed. No one had ever seen this side of the actor before. And the character's passion and grit rubbed off on the otherwise beleaguered actor.

*The Newsroom* saved Jeff's career and helped him forge a connection with a new colleague, Aaron Sorkin. Because of his own experience as a playwright, he felt a kinship with Aaron, and working on *The Newsroom* inspired Jeff to resume work on a number of plays that he had abandoned. When he wasn't shooting the show, Jeff was back at the Purple Rose.

As a playwright, Jeff always wrote his best material when he was angry about something. Toward the end of production on the final season of *The Newsroom*, the public began to hear of water problems in a town in his home state of Michigan—a town called Flint. Like all Americans, Jeff was incredulous that something like this could happen in America in 2014.

At the time, Jeff was performing the Broadway revival of *Blackbird*, a piece he had grown with since its American premiere. The documentarian Michael Moore was in the audience one night, and after the show, they talked for a while. Jeff had seen Moore's 1989 documentary film *Roger and Me*, which documented GM's devastating abandonment of Flint, and he asked Michael point blank, "What can I do about Flint?"

Michael thought for a second and then responded, "Do you know any famous athletes? Could you take them up to Flint for a photo op to raise awareness to the problem?"

Jeff was dumbfounded. A photo op? Surely there was something more he could do than arrange a photo op. He thanked Michael and left the theater, tied up in knots. He needed to do something to bring the story of Flint to the world. That night, Jeff got to work on the first draft of *Flint*, a play that he would spend the next year and a half working on.

*Flint* was a play about the pain of a town adrift amid an economic downturn, set in the kitchen of a typical Michigan family, where they drank water right from the tap. The play debuted at

the Purple Rose in January 2018. There was no doubt that the audience, the actors, and the creator felt the tension of that moment, but in a prepared statement before the performance, Jeff put a more positive spin on the night. "The best plays shine a light on the human condition," Jeff said. "*Flint* is about hope, abandonment, and what happens when good, hard-working people scream for fairness in an unfair world."[1] Once again, Jeff channeled otherwise troubling emotions into works of art that stimulated audiences and artists alike.

To this day, Jeff continues to work across the country, from L.A. to Chelsea to New York. As of this writing, he's again working with Aaron Sorkin, who has cast him as Atticus Finch in the first theatrical adaptation of *To Kill A Mockingbird*. To Jeff, it's just another opportunity to be a better actor today than he was yesterday.

## ARTIST-ENTREPRENEUR TAKEAWAYS

Follow a hard path. Deciding to be an artist means a commitment, as the path is almost never an easy one. Toiling at auditions or in the studio can sometimes seem fruitless, but it must be done. If we look at Jeff Daniels's career, there is one constant: hard work. But Jeff also made life choices that allowed him to make sure that the work he had put in would bear fruit.

Do more than what's required. Jeff worked harder than those around him. He spent hours going over scripts and practicing his lines, so that when the time came, he would be confident in the quality of his performance. Where are you possibly slacking in your artistic endeavors? How could you motivate yourself to get out there and work harder?

Experiment intentionally. In the Purple Rose Theatre, Jeff carved out a space for experimentation. Through his Chelsea,

Michigan, theater company, the actor was able to try on many hats. And being behind the curtain gave him insights into his own craft that he would not have had otherwise. Where can you find opportunities to experiment? Have you explored other areas of your artistic sphere in order to learn more about your own craft? If you're a guitarist, have you tried to learn the drums or to teach yourself a bit about sound engineering? If you're a writer, have you tried copyediting?

Network, network, network! Lastly, Jeff knew how to connect to other artists and creators. He was constantly seeking advice and conversation. From Marshall W. Mason to Jim Carrey to Aaron Sorkin, he was inspired and challenged by his friends and colleagues. And those connections sometimes yielded an invitation to an audition—or even a job. Do you have a friend who can keep you on your toes? Who do you go to when you need feedback or support?

Jeff Daniels once said his whole life was freelancing, going from gig to gig to gig. He had to be hungry to book those jobs, and he had to work hard to do them well. If you're willing to work hard and go against type, there's no telling what you can achieve. Just ask Jeff.

Bill T. Jones

# Bill T. Jones

## *Dancing through Doubt*

It's just after intermission in a high-school auditorium in Wayland, New York. The audience is freshly settling back into the evening's performance of *The Music Man*. Most of them have probably seen the film version made a couple years before in 1962, starring Robert Preston and Shirley Jones. The scene on stage is set in a high-school gymnasium, where a bunch of raucous teens are singing and dancing about dating in their small town.

*"Shipoopi, shipoopi, the girl who's hard to get."* The teens grab each other and pair up, dancing around the stage. Out of the ensemble emerges one tall and lithe black boy, who dances the solo of Marcellus. Now, in most productions, Marcellus grabs girls from the ensemble to dance with throughout the song. But in this production, in 1964 in Wayland, New York, Bill T. Jones was dancing on his own.

The movement of the music surges through him. His limbs, long and strong, extend almost across the entire stage. His hips rock back and forth as his knees bend under him. Without a doubt, he is the best dancer on stage. But unlike the rest of the dancers, he is alone. He dances in solitude for one reason—the color of his skin. In the 1960s in Wayland, New York, it was still considered inappropriate for a black boy to dance with a white girl. So Bill danced without a partner—as he often would.

Bill T. Jones grew up in this conservative town, as the tenth child of twelve. Bill's parents were migrant farmworkers who had relocated to upstate New York. Bill would find himself in the fields

working alongside his parents after school. Crop picking, however, was simply not Bill's specialty. Along with his sister, Rhodessa, he'd be off in the clouds dreaming and dancing—trying to make his body look like the grass that swayed under his feet or the wind that wafted through his hands.

When Bill looked at the world, he saw movement. Music from the jukebox shook his body to dance. Pop culture stars, such as Lawrence Welk, gave him inspiration for steps. The natural world around him would move and he'd move with it. In his small town in upstate New York, however, there weren't many places that accepted the way he moved. Sure, he had talent, but there was no one to appreciate it. The usual pathways to audience and networking simply weren't open to him.

In Wayland, Bill was an outsider. Most of the community were white, middle-class working folks. It wasn't just Bill's race that set him apart: he was poor too. Bill was just *different*. He saw the world from his own unique perspective, and the community at large simply didn't understand him. In town, he was stared at; at school, he was ostracized.

That changed when he met his drama teacher, Mary Lee, who became his protector. When he was picked on for being different, she chastised his bullies. Mary Lee saw real talent in young Bill— talent that had gone untapped. For the production of *The Music Man* that year, it was announced that they'd have a choreographer arrange the dance pieces. The school had never had a choreographer for its productions before, so excitement grew quickly among the cast. Everyone assumed Bill would have the flashiest dance, due to his talent. Unfortunately, the choreographer pulled out at the last minute, leaving the cast and Mary Lee with no footwork. The drama teacher turned to Bill and asked the seventeen-year-old boy if he could do it.

And Bill did what he always did. He improvised.

The night of the premiere, Bill felt validated: a piece he had choreographed and performed had caused an audience to erupt into

applause. He recognized that he had a good body—a body that had been trained for years by track running and field work. He also knew he had a good mind, a more innate faculty that he'd been honing throughout his life. But doubt about his talent had gnawed at him until that night—and would return often throughout his life.

"When are you going to go to Broadway, Bill?" became the refrain at his high school. But Bill wasn't convinced that Broadway was in his future. He knew that to be a performer, you have to invent yourself each day. You have to contain multitudes. You have to be a charmer in order to convince people to let you perform. And he was to learn that you need to be your own champion to see yourself through hardship. And perhaps most importantly, you need to be in the right social, political, and geographical moment. For Bill, this meant escaping Wayland.

In 1970, the young dancer graduated. Thanks to a program for underprivileged students, Bill headed to Binghamton University, where he studied dance. While only two hours outside of Wayland, Binghamton represented a spiritual escape for Bill. He began to study African and African Caribbean dance in an effort to polish his raw talent. He began to hear a lot about the renowned Alvin Ailey American Dance Center; his fellow dancers would tell him, "You should go to New York and have Mr. Ailey finish you."

But Bill didn't want that. He didn't want someone to "finish" him. He wanted to continue exploring himself. At Binghamton, he was coming into his own—both as a dancer and in terms of his sexual identity. His body was his own, and he didn't want Ailey or anyone else to tell him what to do with it. Bill had a tendency to rebel against what he felt was expected of him, and that included attending Alvin Ailey's school of dance. Unlike those entrepreneurs who draw on the wisdom of their elders, Bill found strength in iconoclasm, individuality, and improvisation. Bill would determine the course of his own future.

But there was something else that was changing Bill's life—or rather, some*one*. His name was Arnie Zane, and he couldn't have

been more different from Bill. A short, well-built Bronx native with Italian and Jewish roots, Arnie was an alumnus of Binghamton who had graduated several years before with a degree in theater. At the time, however, he was focusing on his photography. Arnie was obsessed with the movement of the body and how that movement could be expressed in a still image. Their similar passions brought Arnie and Bill together in the small college town, and their attraction was immediate.

Bill and Arnie met at a "coming out" party during Bill's first semester at Binghamton. Arnie looked at Bill in a way he had never been looked at before—like he was a piece of art to be hung in a gallery. In the spring, Arnie traveled to Amsterdam, and Bill followed him. Bill was a young freshman, and Arnie was his passport to the world. The two of them gathered up their belongings and started an adventure that would last their whole lives.

Many were shocked by the couple's decisions—both to leave school and to take each other as lovers. Bill's parents, although confused, eventually came to accept the relationship. Arnie's father was not so accepting—and chased Bill out of the Zane family diner with a meat cleaver.

The difference in their appearance made the two of them a striking pair—Bill tall and black, Arnie short and white. They were young and talented, and they were in love. For the moment, Bill's doubts about his talent receded.

Enamored of his new life, Bill learned more about who he was in Amsterdam. Hand in hand, he and Arnie took in every new experience the city had to offer. It was a first chapter for them, and Amsterdam revealed who they were to each other and to themselves.

While in Amsterdam, the couple became acquainted with a group of avant-garde artists who challenged the accepted ideas about movement, language, and image. In these challenges, Bill and Arnie would find the seeds of inspiration for several of the duet pieces they would eventually choreograph later, such as *Floating the*

*Tongue.* In these experiences, Bill's vision of Arnie came into focus. He cherished his perspective, and he knew that Arnie was his life partner—both in love and in work. This world of companionship and support—without judgment or prejudice—encouraged Bill to experiment and grow as an artist.

Invigorated by their European experience, they settled in New York City, where Bill's identity finally lined up with his geographic space. He'd found a home where he could fully be who he was, a peer group that supported him when the general public wouldn't. That being said, he still had questions about what he was to do in this world. What was the mark he wanted to leave? What did he want to say, and how did he want to say it?

Bill and Arnie soon learned about the dancer Lois Welk (great niece of Lawrence Welk) and her new style of movement known as "contact improvisation" or "contact improv." In an effort to explore how the human body works in tandem with other bodies in space, Welk's style played on how performers find their centers of gravity through other bodies. The style required movers to be in constant contact, "listening" to their partners through their own corporeal selves, every moment a readjustment to fit into the ensemble or to support a partner. Through this contact, movement would emerge as if spontaneously created by all parties.

Welk, an avid student of movement, was interested in how contact improv would work with different bodies from different backgrounds. She cast her net wide, advertising her first workshop to disco dancers, wrestlers, lovers—anyone who *moved.*

Bill and Arnie walked into the workshop with open hearts. Arnie had never even taken a dance class, but improvisation was second nature to Bill. At the end of the day, the participants were sweaty and worn out, and the next day only Bill and Arnie came back for round two.

In these improvisations, Welk saw the electricity between Bill and Arnie. While not technically a dancer, Arnie's natural tight and fast movements complemented Bill's legato movements and

the long lines of his limbs. Arnie and Bill seemed weightless together. Bill had found a new way to express himself: it wasn't polished or even always choreographed, but these movements were *his*. Together Welk, Arnie, Bill, and other improvisers founded the American Dance Asylum in Binghamton, New York.

The Asylum, or ADA, was meant to be a safe haven for dancers to try out radical forms of movement. Through contact improv, collaborative work, and iterative rehearsals, dancers at the ADA got a chance to create their own pieces of movement and choreography. These performances combined Arnie's photography with Bill's poetry and often involved spoken word, projections, non-dancers, and riffs on various styles of dance. One of these pieces, *At the Crux*, featured projections of Arnie's photography and a duet with a non-dancer—a woman Arnie had found on the street.

During his time at ADA, Bill worked on quite a few solo pieces. As the Asylum was a safe place to experiment, he was constantly trying new things in his performances. He would try a step, decide he didn't like it, and then try a new thing. During this time, he was working through the discomfort of not knowing what would come next. For a dancer, this discomfort could be deadly—miss a step and you might break your leg. But as a committed artist, Bill didn't want to bring something to his audience that wasn't a risk for him as a performer. Besides, he had grown accustomed to improvising, having needed to adapt to social instability all his life.

During this time, Bill created his 1975 piece *Everybody Works/All Beasts Count*. The solo was a reflection on Bill's life from the beginning. He combined his movements with poetry that he'd written, adding verbal illustration to the dramatization of his experience and emotions.

*Everybody Works/All Beasts Count* caught the eyes of New York City producers, and soon after it debuted at ADA, it was picked up for performances at several NYC venues, including the Dance Theatre Workshop, the Kitchen, and the Clark Center. Bill began to get more and more solo work in the city, which pulled him away

from his colleagues at ADA. Gradually, Bill and Arnie began to drift away from their colleagues artistically as well as geographically, and in 1979 they left the Asylum and moved back to the New York City area.

Together, they began crafting new duets together. The couple created a trio of duet dance pieces that dramatized their natural complementary rhythms. One of these was *Blauvelt Mountain*. In this piece, Bill and Arnie maintained their signature rhythms while they constructed a wall on stage, only for that wall to be torn down by the end of the performance.

Bill and Arnie's pieces were unlike anything else that was happening in dance at the time. By combining text, media, and choreography, the couple addressed social and ethical issues in a way that spoke to the world in which they lived.

In 1982, Bill and Arnie formed their own company, the Bill T. Jones/Arnie Zane Dance Company. They opened their doors in Harlem in 1983, and that year they held their first performance, *Intuitive Momentum*, which also featured jazz drummer Max Roach.

The company was flourishing, and audiences were breaking down the doors to the theater. Critics praised the new and inventive take on dance. Anna Kisselgoff of the *New York Times* wrote, "Mr. Jones and Mr. Zane are first and foremost, charismatic performers . . . a physically impressive performance to marvel at."[1] Every day, new audiences from Boston to Paris called on the company to perform on their stages.

Despite all this praise, however, something was off within the company—more specifically, something was wrong with Arnie. Rashes. Fevers. A tooth infection that wouldn't go away. One day he collapsed in a rehearsal studio. Bill took Arnie to the doctor, and the diagnosis was dire. Arnie had AIDS. And Bill was HIV positive.

It was a punch in the gut—one that gay men felt every day in the 1980s. And the bruise was spreading, as AIDS claimed new victims every day. By 1984, when Arnie was first diagnosed, there had been more than seven thousand AIDS diagnoses in America—and more than three thousand deaths.

The company reeled at the news. No one knew what to do. "It was not a good time," recalls Amy Pivar, one of the principal dancers. "We didn't know what AIDS was, except that Arnie would be really tired and take a nap in the corner of the rehearsal studio."[2]

Over the next few years, Arnie got progressively sicker. In 1988, he was treated for a lymphoma that unfortunately exacerbated his condition. On March 30, the dancers of the company gathered at Arnie and Bill's home in Valley Cottage, New York. They spent the day celebrating Arnie and his life. That night, with Bill holding his head, lying in the bed that they shared together, Arnie left this world.

Bill felt Arnie's absence keenly, and it was excruciating. In a private moment, Arnie had mentioned to Bill that he didn't need to keep the company—that he could go back to being a soloist. For Bill, though, the company was the child he'd had with Arnie. He couldn't let it die. He needed to use it to find Arnie again. So over the next year, the company created new pieces to channel their pain at the loss of their founder.

*Absence*, a performance that grew out of this period, was a meditation on loss, grief, and found love. While it was not uncommon for the company to address personal issues, the loss of Arnie had completely transformed the nature of their performances. The frenetic energy of Arnie's movement was replaced by a somber, searching quality. One critic wrote, "Quirky movement and fragmented gesture, often performed at a high-energy level, have gone hand in hand in this troupe. . . . This season is different, and the emotions and meanings behind the new works . . . reflect that difference."[3]

Over the next couple of years, the Bill T. Jones/Arnie Zane Company continued to grow, devising new pieces, forging new partnerships, and educating new generations of movers. While the loss of Arnie had wracked Bill, he discovered that in order to reach his audiences, he needed to reveal himself. The ultimate unimaginable thing had happened, and Bill had to adapt more so now than ever before.

In 1994, the Jones/Zane company produced *Still/Here*, a reflection of the pain Bill felt about his own HIV diagnosis. *Still/Here* featured terminally ill dancers performing pieces that illustrated their pain. At the time *Still/Here* was criticized by some critics who didn't think the pain of the dying was meant to be consumed on stage. Others complained that the nature of the piece made fair critical evaluation impossible. "By working dying people into his act," one critic wrote, "Jones is putting himself beyond the reach of criticism."[4] Bill was changing the definition of dance and challenging audiences and critics to think differently.

Through his company, his solo work, his choreography, his writing, and his advocacy, Bill T. Jones has revolutionized the world of dance and movement. With two Tony awards, a Kennedy Center Honors, and a National Medal for the Arts, Bill is one of the most influential voices in twenty-first-century choreography. To this day, he continues to create inspiring pieces that engage his audiences.

From a young age, Bill had experienced pain that set him apart: the pain of racism, the pain of criticism, the pain of diagnosis. Throughout his career, one thing has stayed with him—doubt. A lack of confidence in himself and in his abilities stretches all the way back to his performance in *The Music Man* in Wayland. And yet, Bill partnered with that doubt, became comfortable with it, so that he could make the work that he knew he was destined

to make. He evaded pressure, prejudice, and marginalization by embracing experimentation, spontaneity, and a community of supportive peers.

Looking back on his life, we can pick out a few of Bill's strengths that helped him overcome doubt during his time of creation. (We all experience doubt like Bill's.) While none of us may have every facet of Bill's perspective, there are a few things that we can learn to try to emulate the choreographer—to follow in his dancing shoes.

## ARTIST-ENTREPRENEUR TAKEAWAYS

Build your village. At every stage of his life, Bill found supporters and mentors. From Mary Lee to Arnie, Bill knew he needed people he could count on and who could encourage him. He sought out new collaborators every day. Bill knew the importance of having a strong network of friends who can rescue you when you feel like you're floundering. Who are the people in *your* life who lift you up? How could you grow your own network of supporters and friends to help you stay focused when failure seems to lurk around every corner?

Let your business be personal and vulnerable. It's clear that Bill's work was always very personal. Bill used his work to overcome his doubt. Just like the theory of contact improv, Bill would shift and move to find the right position to lift himself up out of doubt. He put his full self into his work, and this vulnerability in the face of doubt is what led him to such great pieces as *Beasts*, *Absence*, and *Still/Here*. Where are *you* holding back? What doubts do you have about your work? How can you bring those things into your workspace to gain a better understanding of yourself and your art?

Be your authentic self. As a creative, your identity is insepa-rable from authentic work. While the pain of being an outsider plagued him when he was young, Bill came to cherish his own perspective and identity as he grew older. He brought it with him from the American Dance Asylum to the Jones/Zane company to his own solo work. He found that when he could be solely him-self, his talent grabbed his audiences' attention. While at first his identity separated him from others, ultimately it was the thing that made him stand out. What do *you* bring into a room that makes you unique? Do you think of those things as gifts? How can your identity shine through your work?

Doubt is your friend, not your enemy. Doubt plagues us all. At every stage of your career, your doubt and insecurity will under-mine you and your passion for art. But doubt is a test. It's natural for you to question yourself, but these questions shouldn't hold you back. Bill T. Jones learned that doubt is like a dancing partner. It moves with you and sometimes fights against you. But learning not to fear your partner will make your art more fulfilling and re-warding. Bill used his doubt to find himself, and he's still dancing with it to this day.

Lin-Manuel Miranda

# Lin-Manuel Miranda

## *Taking His Shot*

At the last stop on New York City's fabled A train, there's a small neighborhood called Inwood. It's about as far north on the island of Manhattan that you can go. Home to thousands of Dominican and Puerto Rican immigrants, Inwood is a vibrant community of apartment blocks, cafés, and *tiendas*. If you stand on the corner of West 207th Street and Broadway, the neighborhood will fill your ears with salsa beats and hip-hop rhymes. And flowing out of one window in 1990, you might have heard a vinyl record scratching out *West Side Story*. That window belonged to the Miranda family, and a young Lin-Manuel Miranda called that building home.

Lin-Manuel Miranda grew up bathed in the music of Inwood. The child of a psychologist and a political consultant, he was taught the value of working hard and sticking to your passion. He was also raised to love music. His parents would fill their small apartment with the sound of musicals from the golden era—*Carousel, The Sound of Music, Camelot*—transporting Lin-Manuel to a world far from his own.

But when he left each day to catch the train to school, he'd be taken in by the sounds of the city: the boom boxes pumping out tunes for the break dancers on the cardboard, the radios in the bodegas playing Dominican merengue from Juan Luis Guerra or Héctor Acosta, the freestyling rappers in the subway, even the rattle of the train as it lurched underneath Eighth Avenue had a musicality that inspired Lin-Manuel. His ears were attuned to every sound and vibration that New York had to offer. But there was one more place that would affect his ear—and his soul.

Every summer, Lin-Manuel would visit his *abuelos* in Puerto Rico. And each year, he would be surrounded by a whole new world of sound. In Puerto Rico, he heard his heritage clearly through the beats and rhythms of the island. To Lin-Manuel, these sounds were natural, normal, and of his heritage. But when he'd come home in the fall, he'd often find himself the only Latinx in the classroom. From a very young age, he learned to "code-switch," or alter his personality to fit the company he was keeping.

Lin-Manuel was enrolled at the prestigious Hunter College High School. At Hunter, he was working to shape the sounds he heard every day into something—a piece of theater or a song that would delight and entertain. He worked hard to succeed at Hunter, while the sounds of inspiration from the city continued to reverberate within him.

It was at Hunter that Lin-Manuel first felt the spark of creativity that lives in all entrepreneurs. As a sophomore, he joined a student theater group called Brick Prison, whose mission was to create a place for students to write and stage fully formed theatrical works. Each year Brick Prison produced five one-act plays by their student members.

He distinguished himself as both a writer and an actor, and his fellow students' work inspired him to write his own one-act plays. He spent the rest of his high-school career dreaming up new plays and getting them down on paper as quickly as he could. These new works were seedlings of ideas that would lead him to his ultimate passion.

Lin-Manuel measured his high-school life in these performances. Each year brought a new opportunity to write and perform. The young writer was enraptured by the roar of the crowd during his plays and the quiet focus that came when he performed them. Each day he took in the city as he walked to school, where he'd put those experiences down on the page. Then he'd work with his friends to lift that work off the page and onto the stage. The stage at Hunter, however, wasn't the only place he was spending his time.

Another benefit to living off the A line was Lin-Manuel's proximity to the greatest theatrical offering in the country—Broadway.

The biggest musical during his high-school years was *Rent*, the bohemian rock-opera that portrayed starving New York artists struggling to make it through the HIV/AIDS crisis. The arrival of *Rent* signaled to Lin-Manuel that new sounds, new faces, and new voices were coming to Broadway. The show inspired him to dream of how his own voice could join that chorus.

While *Rent* was winning awards and packing houses, there was a different Broadway show that caught Lin-Manuel's attention—Paul Simon's Broadway musical, *The Capeman*, at the Marquis Theatre. A blend of doo-wop, gospel, and traditional Latin music, *The Capeman* tells the true story of Salvador Agrón, a gang member in the 1950s who is imprisoned for the murder of two young teenagers but who finds his true self during his incarceration and devotes his life to poetry. *The Capeman* was met with mostly negative reviews (although the cast's performances and Simon's music were generally praised) and even protests from the families of Agrón's victims. However, it wasn't the controversial content that captured Lin-Manuel's eye but the casting.

The cast of *The Capeman* was led by Marc Antony, Ruben Blades, and Ednita Nazario. Lin-Manuel hadn't seen a Broadway production with multiple Latinx leads and here there were three. Lin-Manuel was seeing people who looked like him up on stage performing songs inspired by the music of his people. But still, the show was portraying Latinos as gang members, which was not Lin-Manuel's experience of growing up in New York City. *The Capeman* didn't last on Broadway, but it made a lasting impression in Lin-Manuel's mind as representative of the kind of music and story Lin-Manuel would want to write about *his* community. He was able to not just observe others' work but also learn from it: from his predecessors' successes and their challenges. Employing a skill set that every artist entrepreneur must possess, he developed a new style by letting himself be informed by others, inspired by others, but never sculpted by them. Ultimately his work relies on his predecessors, yet it embodies a creative expression that is unique to Lin-Manuel's distinctive voice and perspective.

Lin-Manuel graduated Hunter in the spring of 1998 and that fall headed to Wesleyan University in Middletown, Connecticut. He would continue writing while continuing his education and exploring his developing interests and passions. He was curious about how music, theater, and heritage could collide in new ways that were unique to the Latinx experience. He became heavily involved in both the theater department and the student-run Second Stage theater community, performing in many plays and musicals. At the same time, he was working on songs for a new show that became the initial version of *In the Heights*.

The original version of *In the Heights* was shorter and focused more closely on Nina and the disparity she felt between college life in Connecticut and her relationships with family and friends back home in New York. This was a close correlation to the circumstances Lin-Manuel was working through in his own life at the time. With a first draft in hand, he applied to Wesleyan's student-run theater, and it was accepted for a weekend production in the spring of Lin-Manuel's sophomore year. Lin-Manuel directed the piece, but he did not perform in it. The first production was what college productions are designed for; it allowed Lin-Manuel to get all his ideas out on stage and see which ones worked. By combining Cuban, Puerto Rican, and Dominican rhythms with popular styles like hip-hop, Lin-Manuel poured everything he had learned up until that point into *In the Heights*. It was an early defining moment for him as a creator, but there were still many miles to go for *In the Heights* to travel before it became the show we know today. Ultimately, he created a form that permitted the expression of his varied cultural and musical influences while still resulting in a coherent, unified artistic story.

The Wesleyan production of *In the Heights* got a great response from students. After seeing the play, several seniors and alumni—including Thomas Kail, who would turn into a lifelong friend and

collaborator—approached Lin-Manuel and encouraged him to continue to work on the draft. Lin-Manuel worked on many other projects in college, including a senior thesis that was not connected to *Heights*, but continued to think about how he could expand the original play to incorporate the story of other Latinos. After graduation, Lin-Manuel continued that conversation with Kail about *Heights*. The two worked on the show together through a series of workshops with Backhouse Productions that Kail directed in the basement of the Drama Book Shop in NYC. That's where the musical caught the eye of producer Jill Furman and later Jeffrey Seller and Kevin McCollum, who had previously produced *Rent*. Book writer Quiara Alegría Hudes came on board, and Lin-Manuel got the opportunity to further refine the show at the National Music Theater Conference at the Eugene O'Neill Theatre Center in Connecticut. Lin-Manuel wrote many drafts of the piece with Hudes, and Kail served as the director for several iterations, including the eventual Broadway run.

Working tirelessly draft after draft, Lin-Manuel radically changed *Heights*. None of the original songs from the Wesleyan version made it into the final version of the shows, and Lin-Manuel wrote dozens of songs along the way that came and went as the musical took new shape. Original characters faded away and new ones emerged. *In the Heights* became a story about a community defining and redefining home. The narrator, Usnavi (portrayed by Lin-Manuel in the Off-Broadway and Broadway productions), is a young Dominican bodega owner whose parents immigrated to Washington Heights to seek a better life for their son. He introduces the audience to the rest of the residents of his barrio—the Rosarios, Benny, Vanessa, and the matriarch of the neighborhood, Abuela Claudia. Each character in *Heights* is wrestling with his or her individual idea of home and heritage. With *Heights*, Lin-Manuel sought to express all the experiences, passions, and dreams of a neighborhood into one two-and-half-hour performance.

The idea of wrestling to find a home was not simply a fantasy Lin-Manuel dreamed up: he lived it every day. With *In the Heights*,

he found a way to express his own identity and personality without an iota of shame or hesitance. Lin-Manuel didn't have to code-switch anymore. The show was still his but had grown much bigger than just him. It showcased experiences many others had shared but that they had never seen reflected on the stage. Influenced by many, he spoke for all.

On February 14, 2008, *In the Heights* premiered at the Richard Rodgers Theatre on Broadway. It ran for three years and more than one thousand performances. The production won four Tony Awards (including Best Musical) and one Grammy (Best Musical Show Album).

When Lin-Manuel accepted the Best Score award at the 2008 Tonys, he rapped out an emotional acceptance speech:

> I used to dream about this moment, and now I'm in it. . . . I know I wrote a little show about home. Mr. Sondheim, look, I made a hat. . . . It's a Latin hat at that . . . and with that, I want to thank all my Latino people. This is for Abuelo Wisin and Puerto Rico.

To Lin-Manuel, the Tony was more than just an award. It was a signal that he belonged and that his heritage made him strong—different wasn't bad. More importantly, however, Latinx performers were finally telling their stories on the Broadway stage. With *In the Heights*, Lin-Manuel captured the imagination and attention of artists and audiences around the world, eager to see what other stories he would bring to the stage.

In the course of the Broadway production, Lin-Manuel found lifelong friends and collaborators he'd cherish more than any Tony. These collaborators included Alex Lacamoire, the arranger and orchestrator who served as the music director for *Heights*, and Javier Muñoz, who took up the role of Usnavi at various key points during the development of the show and after Lin-Manuel left the Broadway company. Both would follow him years later to *Hamilton*.

At only twenty-eight, Lin-Manuel had the world's eyes on him. Despite his great success and his near-limitless energy, the wunderkind was exhausted. Having completed the 2008 Tony campaign season and still performing eight shows a week in *Heights*, he decided to take a break—he needed to get away.

While on vacation, Lin-Manuel brought along some light beach reading—Ron Chernow's biography of Alexander Hamilton. He immediately felt a strong connection between his father and Hamilton, whose lives were so similar. Both were from an island in the Caribbean. Both left through force of will and a desire for education to find homes on the island of Manhattan. While Lin-Manuel shared the voracious appetite for writing, both his father and Hamilton had an endless drive and heated ambition. In Hamilton the man, Lin-Manuel saw much of his father, and in the arguments of the Founding Fathers, he saw hip-hop beef. He soon began to work on his next obsession—songs based on Hamilton's life.

Shortly after returning from his vacation, he got his team back together—including Kail and Lacamoire—to start working on . . . something. In the beginning, Lin-Manuel was not sure what the finished project would look like, but he knew the story was musical. The idea took on the name *The Hamilton Mixtape*, intended as a concept album, like the original *Jesus Christ Superstar*, that could possibly become a stage show in the future. His first song from this project debuted at the White House Evening of Poetry, Music, and the Spoken Word in 2009. Invited to perform selections from *In the Heights*, Miranda instead offered to bring them something new, a song from the perspective of Aaron Burr called "Alexander Hamilton." People laughed when he announced what he was doing. They stood and applauded when he was done. *Hamilton*, just like *In the Heights*, went through years of writing, workshops, and iterations before it got its own shot at Broadway.

It was clear from the beginning that *Hamilton* was going to bring a level of success rarely experienced in musical theater.

When the show premiered Off-Broadway at the Public Theater in 2015, advanced ticket sales were unprecedented, and word-of-mouth reaction was rapturous; the production quickly transferred to Broadway that summer. With lines around the block for every performance, the revolutionary musical broke every box office record when it grossed over three million in ticket sales in one week. Demand continues to soar for *Hamilton* tickets, so much so that their unavailability is a joke among New Yorkers and resale ticket prices are anything but cheap. But Lin-Manuel didn't create the show for only the wealthiest of Broadway theatergoers. Wanting to make sure that young people of color had access to the show, he partnered with the producers of *Hamilton*, the Gilder Lehrman Institute of American History, and the Rockefeller Foundation to figure out a way not just to make it easier for these kids to get in the doors of the Richard Rodgers, but to have it be connected to an innovative education experience.

With all these partners at the table, Lin-Manuel and his family created the Hamilton Education Program, which seeks to serve more than 250,000 Title I high-school students over a five-year period. The program features innovative curriculum based on original historic documents about the Founding Fathers and the era in which they lived. In order to stimulate their creativity, the Hamilton Education Program requires students to create original artistic pieces inspired by the source material. The program culminates in a full-day experience for students and teachers that features student performances and a Q&A session with the *Hamilton* cast, followed by a *Hamilton* matinee.

Possessing considerable backing by these two institutes for the New York production, Lin-Manuel hoped to expand the Hamilton Education Program beyond what the Broadway production could accommodate. Now with a sit-down production in Chicago and two national touring companies crisscrossing the nation, the producing partners have been busy building Eduham programs for schools in tour cities, with an initial five-year plan in the works.

In the summer of 2015, people were knocking down the doors of the Richard Rodgers Theatre for tickets. The theater instituted a *"Hamilton* lottery"—customary for Broadway shows—in which random participants are selected for forty-six tickets in the front two rows. The advent of online lotteries (where people enter through an app on their smart phones or the comfort of their laptops) was just around the corner, but for this summer, thousands of people would show up in person to throw their names in the *Hamilton* hat, although the odds of winning a ticket were vanishingly small.[1]

Seeing that so many people were gathered outside, Lin-Manuel started Ham4Ham, a preshow performance for the hopeful many. Cast members would gather outside the theater before the winners' names were pulled to give a short performance showcasing their different talents or fun interpretations of songs from the show. Lin-Manuel also invited special guests from other shows that were currently on Broadway to take part in the fun. In this way, Lin-Manuel fostered a sense of community between performers and the theatergoers and celebrated the talent Broadway had to offer.

In *Hamilton*, Lin-Manuel found not only a vehicle that changed the face of the American musical but also a platform with which to promote social awareness and change. To this day, he continues to advocate for public education, equality, and lifting up the voiceless.

One can't underscore enough how much of a cultural phenomenon *Hamilton* has become. It has sparked a renewed interest in theater, history, and hip-hop music to demographics who might otherwise have thought at least one of those three areas was not interesting or relevant to them. Lin-Manuel attributes this to the many "on-ramps" for the musical. If you're interested in history, *Hamilton* gives you revolutionary history. If you're interested in hip-hop and rap, the performers of *Hamilton* spit out words faster than many professional rappers. *Hamilton* shows you that no matter your background, you can succeed in life. *Hamilton* has inspired many young artists of color to make names for themselves.

If Lin-Manuel showcased his Latinx heritage in *Heights*, he created his own artistic identity in *Hamilton*. In the latter, there's a question

that characters pose repeatedly to Hamilton: *"Why do you write like you're running out of time?"* It's not difficult to see Lin-Manuel in that position, furiously writing down his next piece, next rhyme, or next verse. He does it because it's who he is. His art is bigger than himself.

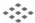

Lin-Manuel Miranda is a visionary with many prestigious awards to his name, including a Pulitzer Prize for his work on *Hamilton*. He's not an anomaly plucked out of obscurity by fate. He crafted his own future. He told his own story. But what can look like overnight success did not happen overnight. All creative entrepreneurs can learn from his drive, his broad set of interests, his active pursuit of key collaborators, and his hunger for new forms. Developing relationships over time, sharing ideas and enthusiasm, and encouraging the talents of your team members helps bring the best ideas out of people, and the best idea in the room wins.

## ARTIST-ENTREPRENEUR TAKEAWAYS

View ideation intentionally. Lin-Manuel had incredible ideas; however, they didn't just languish in purgatory. He applied a discipline and a rigor to developing them. He knew where his ideas came from. He knew who they came from. With *Heights*, he was actively open to feedback; he engaged with other artists and intentionally evolved what began as a more inwardly focused creative work to a more outwardly reflecting piece that captured the experiences of an entire community.

Be passionate about what you do. From the start, Lin-Manuel doubled down on his passion. Whether it was with Brick Prison at Hunter and Second Stage at Wesleyan or countless workshops and productions since, he had his eyes set on key goals that were

aligned with his passions. Whether it was *Heights, Hamilton,* or a one-act he was writing for a student production, he was obsessed with the work he was doing, and his obsession reaped benefits. What projects do you have that you can focus on with that kind of intensity? Give them your full attention and the diligence that honors your underlying core ethos.

Embrace diversity in all forms. Hip-hop, history, and Hammerstein—Lin-Manuel brought all his interests together in his work, and the diversity of his interests was mirrored by the diversity of his audiences. By incorporating influences from a broad spectrum of sources, his work has the ability to speak to everyone. He created something that appealed to a large number of people. But that was never his aim. He was just fascinated by these disparate things, and he had the knowledge and the desire to bring them together in a way that delighted and fascinated others. Are there areas of your life that you find fascinating but tend to keep to yourself? See if you can marry those disparate ideas in your art, and you might awaken dormant fonts of inspiration living inside you.

Use the things that make you unique. Lin-Manuel's enthusiasm is contagious, and today, many young artists see themselves in his success. He continues to have the hunger to create opportunities for himself and those who were like him. Lin-Manuel saw the need for Latinx representation on Broadway, so he made it happen. He carved out a space for himself that many new Latinx artists are now pouring into. Are you getting frustrated with the lack of space or opportunity for your art to flourish? Seek out ways you can make a thing that only you can make. By being true to yourself, you may find a community that will uplift your work to surprising heights.

Embrace your heritage. Lin-Manuel Miranda has evolved his artistic and human sense of self since those early days at his parents' home in Inwood that shook with the sounds of the city. Today he still lives in the community, working tirelessly on his next big thing . . . because in a way, he can never leave Inwood behind. He just brings the vibrations and verve of that inspirational community to a wider audience through the power and medium of his artistry.

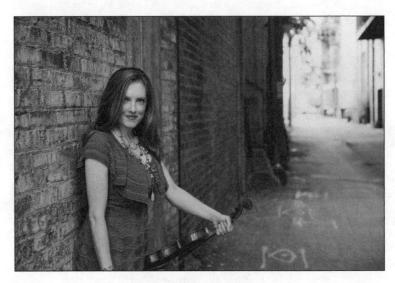

Rachel Barton Pine

# Rachel Barton Pine

## Playing through Adversity

It was Christmastime, and the five-year-old little redheaded violinist clutched her violin tightly as she was ushered through the retirement home. She was there with her parochial school group to play carols for elderly residents, and she moved from hospital room to hospital room playing snatches of "Silent Night" and "O Tannenbaum" on her miniature violin. Before she entered the next room, she was stopped by one of the nurses.

"The man who's in this room . . . I just want to warn you that he doesn't speak," the nurse told the girl. "He has been unhappy since he came here a few months ago. He didn't want to leave his home, so he has refused to speak since he arrived here. We just wanted to warn you about that, so you're not surprised."

The girl *was* surprised, but she shrugged off her confusion, entered the room, picked up her bow, and began to make music. She had played this carol to many patients that day, so at this point her muscle memory took over and brought the melody out of the instrument flawlessly. At some point, however, her eyes were drawn to the old man's face. It was wet with tears, and he began telling her that he had played the violin as a child. As she turned to find her mom and the polite nurse, she saw both of them in tears. The music she shared created a communal intimate moment that inspired the man to speak for the first time since arriving at the home.

That young violinist was Rachel Barton Pine.

Two years before Rachel stepped into that nursing home, she attended a church service in her hometown of Chicago. Before the sermon, a group of middle-school-aged girls stood up and began to play the violin. Three-year-old Rachel was transfixed. She pointed at the girls and announced to her parents, "I want to do that!"

It wasn't until Rachel got her hands on her first violin that her parents realized they had something special. She begged them for lessons, and there was a violin teacher in her neighborhood—and by age four she was playing Bach in front of her congregation for Sunday morning worship.

Playing in church gave Rachel a sense of purpose: she was sharing her gift with her community and congregation. When she performed before the altar, she felt the music ringing out from her violin and surging throughout the sanctuary. Joy filled her as she gave of herself freely to the music and the spirit of worship.

With each new concerto, sonata, or fugue she learned, Rachel's love of the violin grew into a lifelong bond. She threw herself completely into learning everything the instrument could do. She does so to this day. From classic church songs to classical pieces, Rachel found joy in all the music she learned, and as she grew older, her taste in music became more and more diverse and her appetite for learning more voracious. It was a sustaining relation-ship to music.

At seven, Rachel performed as soloist with the Chicago String Ensemble. At ten, she was soloing with the Chicago Symphony. While this was an extraordinary accomplishment for any young violinist, to Rachel, this was no big deal—after all, she had been practicing for her stuffed animals every day since she'd first picked up the instrument, so performing was not only familiar but joyful. This was just another opportunity for her to be a conduit for the music she loved so much and to uplift the spirits of a new audience. Any doubt disappeared in her bond with her instrument.

In order to get to this point, Rachel chose to put in four to five hours a day of personal practicing. Noticing her passion—and the amount of time she was spending on practicing and rehearsals—the principal at her elementary school approached her parents and suggested that they might want to try homeschooling for a bit in order to give Rachel more time to pursue her passion. So in third grade, she left school so that her mother could teach her at home.

Her mother's approach to homeschooling was an unorthodox form of learning known as "unschooling"—a pupil-directed pedagogy that sought to decouple learning from the traditional boundaries of the school system. Both her parents agreed that they should give Rachel the freedom to pursue whatever she was curious about, even if it wasn't on a strict curriculum. For example, if Rachel expressed interest in the women's suffrage movement of the 1920s, they would pack up, head to the library, and read everything they could find on the subject until Rachel felt satisfied. Then they'd head home for another multi-hour violin rehearsal.

In this new environment, Rachel flourished. Finally, without a strict schedule and syllabus, she could breathe. No longer was she rushing home from a full day at school, scarfing down dinner, doing homework, and then immediately getting into the car to go to a recital or a rehearsal. They spread her homeschooling over the entire year—seven days a week, fifty-two weeks a year. Doing fewer hours of academics each day gave her time to learn, practice her violin, and give frequent performances.

Although Rachel's schooling was going well, the Barton family began to encounter financial problems. With her mom at home teaching and her dad struggling to find work, Rachel's family often went without. Rachel's recital gowns were usually thrift-store finds that had been fixed up by her mom, and more than once the family was unable to afford their bills after paying for the gas to get Rachel to her engagements, resulting in utilities such as the phone and electricity being shut off.

However, by the time Rachel was fourteen, she had begun to play for weddings, pick-up orchestras, and corporate parties to piece together an income for her family. But even before then, by age eleven, she had made such a name for herself in the Chicago classical music scene that several of her teachers suggested she audition for the Civic Orchestra of Chicago, the training ensemble of the Chicago Symphony Orchestra—and a setting meant for young adult musicians. Rachel was half the age of most Civic Orchestra members, but she auditioned and got in. Even at this young age, she exhibited a key trait of successful artist-entrepreneurs—pursuit of goals regardless of the difficulty. Most would assume that someone her age could not become a member of Civic and would discourage her from even attempting the audition. She welcomed the challenge with open arms as it was the logical next step in her journey toward her overall creative goals.

Playing in the Civic Orchestra, Rachel had the opportunity to work with famous conductors such as Georg Solti. She learned what it meant to be a violinist in an ensemble and how to find joy in supporting a soloist. She also gained a new group of friends, mentors, and teachers, including Michael Morgan, the primary conductor during her tenure and one of only a few African Americans to hold such a leadership position in the classical music world.

While the program for the orchestra was mainly standard repertory, Morgan also brought in historic and contemporary works by little-known Black composers such as the Chevalier de Saint-Georges and Alvin Singleton. To the young Rachel, these works were just more great music. It wasn't until she grew older that she realized how underplayed these Black composers truly were. Her outlook on that was driven not only by her commitment to continuous growth as an artist but also her love of discovery. As she found new treasures amid lesser-known repertoire, she felt that this music deserved to be heard.

As Rachel grew older, she continued to consume any kind of music that came her way whether it be fiddling, early music, Romantic, or contemporary. Curiously, she herself describes the scope of her interests as narrow: anything she loves somehow relates to the violin. So hers is a unique portfolio career, which synthesizes so many facets of learning, of genres, even facets of life: she combines her philanthropic work with supporting young string players and promoting lesser-known and unpublished composers, she gives of her time generously as a guest master teacher and coach, she is committed to board service for other nonprofits, all while traveling the world and managing her own playing.

During her teenage years, Rachel began to get into hard rock and heavy metal, and soon her violin case was decorated with AC/DC, Megadeth, and Metallica stickers. She saw how fans would react to that music—thrashing and headbanging—and she wanted people to feel just as intensely about classical violin. So she began to study what made rock music tick. She learned the style so well that many years later she would be asked to join her idols on stage, and in 1997 she would release *Stringendo: Storming the Citadel*, a collection of violin recordings of heavy-metal standards. The classical music world is rife with adjudication of other genres of music, and the reality is that even mere exploration of these divergent genres represented a significant risk for an emerging classical star. But risk didn't scare Rachel, who like all entrepreneurs had a commitment to her fellow artists and their joint success that outweighed the potential political ramifications.

By the time Rachel was a teenager, her parents had separated, musicians around the world were asking her to perform with them, and she was the primary breadwinner for her mother and

two younger sisters. Juggling her personal and professional lives was becoming difficult for Rachel, and despite being an eternal optimist, Rachel soon faced new challenges that were beyond the pale even for her.

It was a cold January day in Chicago in 1995. Rachel was riding the Metra, Chicago's suburban commuter rail system, on her way to her teaching job at a music school in Winnetka. As the train pulled up to her stop and shuddered to a halt, Rachel picked up her bags and put them on her shoulder. The doors slid open and she stepped onto the platform. Suddenly, the doors slammed behind her—trapping one of her bags on the other side. Unbeknownst to her, Rachel was caught on the straps of her violin case, and the train lurched forward and began to pick up speed.

The train dragged Rachel more than three hundred feet and ran her over before finally coming to an emergency stop. Several passengers ran to her assistance and quickly applied tourniquets— saving her life until the paramedics arrived. Rachel's left leg had been severed, and her right one was severely mangled.

Rachel, however, was not given to self-pity. Of course, she felt grief, but she was also a woman of strong religious faith, and she trusted God to see her through this trial. Her faith supported her and, along with her zeal for life and her music, provided light during those dark times—and two years after being injured, she was touring again. Her focus on what she could bring and what she could share dwarfed any sense of what she might have lost.

During this time, Rachel began to record with Cedille Records, a not-for-profit record label that specialized in classics. While her national and international reputation was certainly growing, the producers at Cedille told her that they couldn't yet sell records on her name alone and suggested that she compile some previously unrecorded music for an album. That was when she remembered the Black composers whose music she had spent so many hours

playing in the Civic Orchestra. Her voracious curiosity took over, as it always did, and she discovered many underplayed concertos by historic Black composers. She came up with a pitch and took it to Jim Ginsburg, the president of Cedille Records. Continuing her unabashed approach to her field, which reflected in her earlier exploration of rock and heavy metal, Rachel was letting her creative integrity drive her professional pursuits. Genuine passion was more important than fads.

Rachel won Ginsburg over and recorded *Violin Concertos by Black Composers of the 18th and 19th Centuries*. The album was extremely successful, and suddenly Rachel started getting numerous calls and e-mails from young musicians of color who had heard her recording. The music of the Chevalier de Saint-George and José White resonated with them, and they wanted to know where they could find more Black composers whose music they might be able to play in their own recitals.

Unfortunately, Rachel only knew these few concertos she had recorded. It saddened her that even these were not widely known, nor were the names of the composers who had written them. This scarcity of information caused Rachel to think back on her own childhood, a time when she'd often had to deal with not just a lack of information but a lack of resources in general. Being a musician was expensive, and there were things that scholarships just wouldn't cover: instrument rentals or repairs, sheet music purchases, piano accompanist fees, the cost of a gown to wear to a recital, or even the cost of transportation to rehearsals, lessons, and concerts. Rachel knew from her own experience how hard it could be for a musician to make ends meet.

While all this was going through her head, a devoted fan of Rachel's passed away and left her his estate. Inspired by this fan's generosity, Rachel decided to use the modest but meaningful gift for something special. She founded a not-for-profit organization

whose mission would be to create opportunities for underprivileged musicians and to promote the study and appreciation of compositions for stringed instruments by Black composers. And so, in 2001, the Rachel Elizabeth Barton (later Rachel Barton Pine) Foundation was established.

Compensating for her relative ignorance in these matters, Rachel staffed the advisory board of her foundation with African American pedagogues and researchers and specialists in Black music. These advisors helped Rachel realize just how alienated African Americans felt from classical music: many young Black student musicians were excited to play the violin but were less interested in solely performing works by White composers. Systems of racism had kept Black composers out of the conversation, and their works were not being taught to instrumentalists. Through her foundation, Rachel wished to help the classical music community recognize the incredible contributions by Black composers to the field.

One of the RBP Foundation's most successful programs grew out of a relationship Rachel forged with Sotheby's auction house. In early 2001, Sotheby's asked Rachel to perform on a Stradivarius violin that was up for auction in New York. Later that year, in October, Sotheby's held another auction in New York. However, the September 11 terrorist attacks caused many potential buyers to change their travel plans at the last minute, and many of the instruments didn't receive a single bid.

The seller of one of them, a fine modern Italian violin, was disappointed not to have made a sale, but she wasn't hurting for the cash; she just wanted to make sure that the valuable violin went to a good home. So Sotheby's asked Rachel if the music school she used to attend would like the violin. Rachel, however, thought that the instrument would be put to better use enriching the lives of the young artists who were served by her foundation. And that was

how her foundation's instrument loan program came about. Since 2001, the foundation has supported more than one hundred young string musicians through instrument loans and financial assistance.

Through the Rachel Barton Pine Foundation, Rachel has been able to pay forward the generosity that helped her achieve her dreams. Despite tragedy, grief, and hardships, Rachel converted those experiences into creative assets, and she's now able to make those same opportunities for others. The cards were stacked against her, but she knew how to make a winning hand out of what she'd been dealt, resulting in one of the most successful performing careers as a concert violinist, thirty-six albums, and philanthropic leadership that has impacted an entire field. In the end, while Rachel's altruism and sense of her moral role in the world drove many of her decisions, ultimately these are best practices for all artist-entrepreneurs as they lead to longevity of creative expression and sustainability of professional careers. Since that day when she was three years old, Rachel's journey with the violin has been characterized by three of her core attributes: focus, curiosity, and generosity.

## ARTIST-ENTREPRENEUR TAKEAWAYS

Be focused. Rachel has a broad set of interests; her focus, however, has really always been on one thing—the violin. Focus allows you to synthesize different interests into a coherent passion and career plan. What is *your* focus? How can you sharpen that focus to grow your own work? What process do you follow to truly connect that focus to your true passion? How do you then cultivate the passion to create a sustainable career or enterprise?

Be intellectually curious. Rachel's curiosity motivated her to seek out different forms of music beyond the classical tradition in which she'd been trained—hence her interest in rock and heavy metal—and to seek out the work of Black composers whose contributions had been overlooked by the classical tradition. Her curiosity also gave her the courage to ask for help when she needed it: if she was inspired by a particular piece of music, she'd find an expert on the composition to give her their perspective. What feeds *your* curiosity? What are the questions you want answered? How can you make connections with experts to answer those questions? Rachel also attributes her comfort and tendency to not get nervous while performing to her ability to view herself as a vehicle, a conduit, removing fear of judgment by others. There is a certain humility and comfort in experimenting with that point of view.

Learning is a constant. Rachel has always taken her curiosity beyond thought. She has and continues to act on it. She has and continues to learn other genres. She has chaired nonprofit boards, started a foundation, discovered rare music and unpublished composers, and is an active participant in countless conferences and forums. She thrives in the learning space and continues to challenge herself.

Embrace altruism as a tool to overcome adversity. It is easy to lose oneself in or fall victim to circumstances. When things look dark, we can often retreat into ourselves and neglect our art. However, in the face of adversity, Rachel showed amazing generosity, resilience, and sense of purpose that paid itself back tenfold. When her family needed groceries or rent money, Rachel played a wedding for cash. When she realized that a lack of resources was hindering the progress of other musicians, she created a foundation to lift them up. And even as a child, when she played for the senior citizens at that retirement home, the generosity of her performance touched their hearts. When things are toughest, how can you give

of yourself instead of clamming up? Where can you create opportunities to perform, and do you think of ways to channel your art form's healing powers? Rachel's performances have moved audiences around the world. To watch her play is inspiring, and to know what she's been through is to understand the meaning of perseverance. In the face of adversity, she offered comfort and joy to others, by using her instrument and sharing her passion.

Damien Sneed

# Damien Sneed

## *Balance Is a Boon*

In the living room of the Sneed household, there was a toy piano tucked in the corner and a television on a credenza. Each night, Damien—age three—and his family would sit around the television and watch whatever was on that night. It was less about catching their favorite programs and more about spending quality time—unless there was a program that covered their favorite topic: music.

The Sneeds were voracious music lovers. They loved to watch any musician, no matter the genre. It would be jazz with Wynton Marsalis on some nights, the Great Performances on PBS would give them their dose of classical music, and—on the rare late-night occasion—they'd catch a rock and roll program. No matter what the music was, Damien's young eyes would light up. He'd pull his toy piano out of the corner and begin to plunk out whatever tune was coming out of the television. His parents would sit amazed at their young child's incredible ear for music.

Damien had good parents. They were constantly encouraging him and helping him to grow his talent. They took him to piano lessons where he learned the placement of the keys based on a color. They bought him albums by rock artists, gospel artists, and classical artists. Hall and Oates, Bobby Blue Bland, and Eugene Ormandy were some of his favorite records. At home, he'd eagerly unwrap them, put them on his turntable, and then play along with his favorite toy piano.

As we have seen with other art entrepreneurs featured in this book, good artists need good parents to grow. And Damien's

parents were some of the greatest. They taught him that balance was important. Over the course of his career, Damien would find this center that would ground him. This wasn't the kind of balance you need when sorting a calendar but an artistic balance—a diet of interests that contained music from all kinds of artists and all kinds of genres.

Damien is a multifaceted artist. At times, he is a conductor, and at others, he is a musician. Almost like an actor in a play, his costume changes depending on where he is needed. In some venues, he's a jazz artist riffing on his piano in a night club. In a concert hall, he's a classical musician accompanying concertos and playing chamber music. In a house of worship, Damien praises God through his music and lights fires in his fellow congregants' hearts. Underneath every aspect, however, is Damien—bright, energetic, and curious.

Damien is a conductor, a vocalist, a pianist, and a composer. He plays the organ and arranges music. While he's recording albums, he's also teaching students music history and performance. Throughout his career, Damien had done a lot and he's not slowing down anytime soon. Taking on these various and diverse roles has taught him how to find balance and stability in a constantly changing field.

As a kid, Damien was fascinated by melody and tone. He'd listen for hours on end to albums from a variety of musical artists—gospel, R&B, jazz, musical theater. After a couple of years of piano lessons, Damien started playing on Sunday mornings for his church. He enjoyed using his music to praise God and to call others to worship. Parishioners loved to hear the little boy play. To the pastor, he was clearly a prodigy. At age eight, Damien became the choir director for the senior choir.

Damien's time directing his church's choir was his first taste of arts leadership. While he might not have realized it at the time,

he was training himself in how to take charge of a group. He was learning how to incorporate the individual into the whole. He learned when a group was strong and how to reinforce that. He also could tell when a group was getting weak and how he could encourage them to rise to a challenge. There was no other way for Damien to get this kind of training but "on the job." By taking on this leadership role at such a young age, Damien learned invaluable leadership skills.

As he grew older, Damien extended his performance style to other areas. Those genres of music to which he loved to listen began to become his favorite to play as well. Sundays were for church and gospel, of course. That wasn't, however, the only place he was playing on a weekly basis. For a local dance studio, Damien accompanied ballet classes where he'd play Tchaikovsky and Prokofiev. He'd learned some of these classical masters by listening to records as a child. He played with his school's jazz band, which taught him improvisation. He even performed contemporary American classics with the high-school choir. Damien's schedule was filling up.

Damien kept all his commitments—no matter how big or small. This loyalty taught him excellence in each of these areas. He'd stay up all night studying a classical piece he'd need to play for a ballet recital even when he had a jazz concert the next day. And it wasn't just music that he was studying. In fact, his high school was a multidisciplinary arts school. During the day, he took classes in modern dance, acting, and even basket weaving. Damien began to see how all kinds of expression weaved itself together into what we call art. That being said, there were other artists who wanted to put Damien into a strict category.

As a teen, Damien entered a competition for young musicians. The competition had a clear bent toward classical performers and composers. Other students from his school were also competing. One of the kids pulled him aside before he signed up and expressed concern.

"Damien," the student said, "I don't think this competition is for you. You play gospel in church."

"So?" Damien replied, but the kid just shook his head. The competition was really just for classically trained performers. Even his peers in the jazz ensemble didn't know why he was choosing to compete. To them, Damien was just a jazz player. But Damien knew he could do it. Despite these naysayers, he entered the competition and won.

Damien never wanted to be boxed in. He always wanted a level of expertise in every area that he studied. And he worked hard to maintain that excellence. He looked up to people like Quincy Jones, who also had a career with many faces. He admired how Quincy was a record producer and an arranger and was able to play multiple instruments. To him, that was the goal to strive for—excellence all around.

Another idol of Damien's was Wynton Marsalis, another arts entrepreneur we'll study. To Damien, Wynton wasn't just a performer—he was a mogul. Wynton built his own musical empire that included not just performing but conducting and teaching. He was a cultural correspondent that taught people across America the importance of music and its power to heal.

Before he went off to college, Damien got the chance to meet Wynton. As a teen, Damien was playing a concert with jazz trombonist Wycliffe Gordon. After one of the concerts, Damien was just winding down from playing. They'd been rehearsing the concert for quite some time, and it had left Damien tuckered out. Much to his surprise, however, suddenly Wynton Marsalis was hanging around the greenroom talking to Wycliffe. That's when Wycliffe introduced Damien to his future mentor. Young Damien was starstruck. He asked Wynton the only thing he knew to say: "Would you like to come over to my parents' house for dinner?"

Wynton obliged and thus began a lifelong mentorship for Damien. In order to learn all he could from Wynton, he'd show up at any show he was playing just to get the opportunity to see

him. He also made himself available, offering to help his mentor in any way possible. Lastly, he'd reach out to Wynton if he had any problems—musically or career-wise as a whole.

Damien's training continued into college. At Howard University in Washington, D.C., he graduated with a degree in piano performance. Then he moved to New York to study the technology we use in making music. He graduated from New York University with a master's in music technology. All throughout his higher education, however, he was in touch with Wynton to ask for guidance or simply to talk shop.

In 2008, Wynton asked Damien if he'd be interested in conducting a piece of his. The piece was one Wynton was asked to compose in honor of the two-hundred-year anniversary of Harlem's Abyssinian Baptist Church—one of the first centers for African American worship in America. *The Abyssinian Mass* was a gospel piece that featured a choir of more than one hundred and fifty and an elaborate orchestra. It was to be performed as a part of Jazz at Lincoln Center, a legendary program founded by Wynton Marsalis.

Damien, always up for a challenge, took up the conductor's baton and performed beautifully. While this was his first time conducting, he no doubt had the skills needed to lead the ensemble. He would later go on to do a sixteen-city national tour of *The Abyssinian Mass*, which would be featured in the PBS documentary *Everyone Has a Place*. For Damien, *The Abyssinian Mass* was a crowning achievement and a huge step in his career as a musician.

His next would be a more personal one, however. Having meditated and focused on the work of his great mentor, Damien was ready to produce his own journey. In 2010, he recorded *Introspections Live* in New York City. *Introspections Live* was a personal essay on his life, his spirit, and his passion. Blending styles of jazz, gospel, and contemporary American music, Damien introduced his myriad talents to the world.

In 2012, Damien would get a chance to work with his mentor Wynton again, performing at the Kennedy Center during the inauguration weekend of President Barack Obama. It was Obama's second inauguration, and the hope that he imbued in the country was filling up the District of Columbia. As a man of color, Damien was honored to be performing for the momentous occasion and to again be with his advisor and friend.

Before they went on that night, he had some time with Wynton alone where he imparted a piece of wisdom that would change the way Damien perceived his art. Wynton pulled him aside and said to Damien: "Jazz is like democracy. It's improvisational. Music has the power to heal and rebuild. I want to challenge you to be more than just a performer. You need to be a leader in the arts. Encourage others, not just with your music but with your actions."

After that, Damien expanded his talents once more into the world of music education. He began to sponsor and teach young musicians to become a new generation of musical leaders. While he had been conducting workshops and teaching small classes for many years at this point, he had the appetite to do something big. In 2014, he scoured every performing arts school in New York City for the best jazz, gospel, and classical musicians. He found more than two hundred young artists to perform Duke Ellington's *Sacred Concerts*—a night of gospel-jazz music.

The recital was performed at Carnegie Hall in collaboration with Wynton Marsalis's Jazz at Lincoln Center Program. While the students were a large part of the performance, Damien also corralled several of his jazz, gospel, and classical colleagues into joining the evening. Even Damien lent his talents as a vocalist to the ensemble.

Damien's career was hitting a high note. He'd orchestrated it that way. His multiple talents and skills had garnered great esteem from all three of his worlds—jazz, gospel, and classical. The Metropolitan Opera House was selling his albums in their gift shops. Auditions and gigs were coming in. In 2014, the Sphinx

Organization—my founding educational organization—presented Damien with its highest honor, the Sphinx Medal of Excellence. With all this success, Damien was ecstatic.

Unfortunately, one of his first fans was in trouble. Damien's mother had fallen ill and there was no one who could take care of her. The multi-career magnate would have to add another job title to his résumé—caretaker. His music career was important to him, but, obviously, family came first. This intimate time with his mother filled him with joy and honor. He had always respected his parents. They'd been his stability and his staunchest supporters since he'd been a child. Now, as a man, he'd have to be that stability for himself and for others.

If Damien's career could fit on one business card, the card itself would be about four feet long. He's taken on multiple roles and gone down many different paths. Throughout it all, however, he's achieved excellence. Today, Damien continues to perform with Grammy Award nominees and winners. He still teaches and empowers students. He still is recording his own work. He's even back at school, studying for another master's degree. This one is in music business. Damien is still juggling gigs every day, but it doesn't look like he's letting any of them drop anytime soon.

## ARTIST-ENTREPRENEUR TAKEAWAYS

When I look at Damien, I see a young musician bright and full of life, eager to take on challenges, despite what difficulties might stand in his way. He's driven. What's more, he has a diverse set of interests and has achieved excellence in almost every field he's taken to. Lastly, Damien has found balance among all these areas, including navigating some tough personal issues. Damien exemplifies the arts leadership that we need in this country right now.

These qualities, however, were not innate. Damien learned them through strong mentor relationships, strong skill sets, and loyalty.

From a young age, Damien was always focused on cultivating relationships with the great masters in his field. He cultivated strong mentor relationships in order to learn and grow from these individuals. Without a doubt, we see that one of the biggest influences on his career was Wynton Marsalis. From the beginning of their friendship, Damien made sure he was available to Wynton for whatever he might need. His openness to help his mentor out created many opportunities for Damien to grow his own career. Now, Damien is the one doing that reach back for a new generation of musicians. From mentee to mentor, Damien has proven that these relationships are invaluable to anyone who seeks to be successful in this world. Who do you know that can be a mentor to you? How can you make yourself available to that person and their needs?

In order for Damien to be of help to Wynton, however, he had to be excellent in his art. Damien spent hours crafting and solidifying his multidisciplinary talent. Damien's strong and diverse skill sets were a boon to him during his career. He spread his skills among different genres to keep him curious, motivated, and determined. As he grew as a musician, his knowledge of various kinds of music grew to on-hand mental encyclopedia. No matter the style of music, Damien could play it. This made him incredibly attractive—not just to his mentor but to audiences as well. And he's created a career for himself that now allows him to draw on all of those musical influences, creating a sound that is uniquely Damien Sneed. What are the genres that you draw upon for inspiration? How can you challenge yourself to take on new genres in your own art?

Throughout all of this, however, was perhaps Damien's most influential trait: his incredible reliability. When Damien made a promise, he made sure he stuck to it. In part this was because of his ability to maintain balance among his several career obligations, but it was also due to his ability to say no. While in this chapter,

we learned about all of the gigs that Damien *did* take, but for every one of these, there were a dozen that he *didn't* take. Damien learned that in order to keep your obligations, you needed to learn how to say no to opportunities that, for whatever reason, you knew you couldn't keep. For every yes, there is a no. Maintaining balance isn't about keeping a full calendar; it's about keeping a schedule that you know you can stick to. What obligations do you have in your career? Do you know which ones are the most important? Prioritizing is key. Make sure you keep the ones that can move your career forward.

Damien's career is far from over. He's a powerhouse of a musician that's dedicated to excellence, able to mentor and give back, and able to tackle several projects at once. He's able to do this all with the grace that comes from a centered life rooted in a strong sense of self. His sense of leadership is inspiring—not just to the next generation of artists, but to veterans like me as well.

Lee Greenwood

# Lee Greenwood

## *Proud to Be an American*

It was Halloween night of 1983 in Los Angeles. Lee Greenwood had just finished performing on the *Solid Gold* television show. As a celebratory gesture, the host, Marilyn McCoo from the 5th Dimension, gave him a bottle of expensive champagne. Lee was not much of a drinker himself, but he took the champagne and politely thanked her for her generosity. With the performance over, Lee headed to the limousine waiting for him.

The country music singer had a red eye back to Nashville that night at 1:00 a.m., but it was only around 10:00 p.m. He still had a couple of hours to kill before boarding. Lee rarely had this much free time on his hands. He almost didn't know what to do with himself.

The lights of Los Angeles sped by his rear window as he contemplated what to do. Absentmindedly, his mind settled on the cassette tape in his pocket. It was a freshly cut demo that he'd recorded right before he left Nashville. An idea suddenly struck him. He tapped on his driver's partition.

"You know where Irving Azoff lives?" he said.

The driver responded, "His place is next to Barbra Streisand's home in Beverly Hills."

"Take me there," said Lee, leaning back.

At the time, Irving Azoff was one of the most powerful men in music. He was the chairman of MCA Music Entertainment Group. They owned the label MCA Nashville to which Lee was signed.

Before Azoff had taken the lead at MCA, many of the labels were suffering. Azoff singlehandedly turned them around. Lee had never met the man before, but he knew that Azoff needed to hear his new recording of "God Bless the U.S.A."

Before long, Lee found himself parked in front of Azoff's house. It was thirty feet across the lawn to the front door. Azoff stood in his door, kissing his three little girls, dressed as bumblebees, as they went off for a night of trick or treating. Lee tucked the unopened bottle of champagne under his arm and got out of the car.

"Trick or treat," Lee shouted as he approached Azoff's front door, extending the champagne and the tape to him.

"Who are you?" Azoff replied.

"My name is Lee Greenwood and I work under your MCA label in Nashville," Lee said. "And I have a song I'd like you to hear."

Irving beckoned him inside and brought him into his living room. Lee handed the tape to Azoff who promptly inserted it into the stereo system. Out resonated the following familiar lyrics:

> I'm proud to be an American
> Where at least I know I'm free
> And I won't forget the men who died
> Who gave that right to me
> And I'd gladly stand up next to you
> And defend her still today
> Cause there ain't no doubt, I love this land
> God bless the U.S.A.!

With eyes closed, Azoff listened to the rest of the song. After it had completed, he opened his eyes and looked at Lee. "Is this attached to a project or a record?"

"Not yet," Lee responded.

"When you get it done, bring it to me in L.A.," replied Azoff.

Two months later, Lee came back to Azoff with a finished album. This time Lee brought his producer, Jerry Crutchfield. Azoff invited his staff of music executives to listen to Lee's entire album. Again, Azoff listened patiently to every song. When it was complete, he turned to Lee with confidence and said, "I think 'God Bless the U.S.A.' should be the single off this record."

But the song would come to be more than just a single. It was adopted by the 1984 Reagan campaign. Lee would play the song at Reagan's second inauguration in 1985—and would play for the next three Republican presidents. It also became Song of the Year at the Country Music Awards in 1985. The song was a rallying cry to armed forces in Operations Desert Storm and Enduring Freedom. And it would unify a country after the horrendous attacks of September 11, 2001.

Lee had created a new anthem for America's twenty-first century, but Lee was no one-hit wonder. There's more to Lee's artistic journey than just this patriotic song. Lee always wanted to leave his audiences with a sense of enlightenment and joy. But doing that was no easy task, especially the size of audiences for which he was now playing. He spent decades honing his craft, building connections, and taking calculated risks, which primed him to become the voice of a new American generation.

Lee Greenwood grew up outside of Sacramento, California. His family were poor sharecroppers, but to hear him talk about it, he didn't want for much. He was born in 1942 while his father, Eugene Greenwood, served in the Navy during World War II. Lee was living on a small farm in North Sacramento. As a teenager, every morning, he would milk cows, tend to the crops, and toil until about sundown. His family wasn't religious, but they'd send him to church for the stability and the morality. In the church, he'd first discover his love of music by singing in the choir.

While his mother was also a musician, their relationship was anything but collegial. Her strict style of teaching the piano caused Lee to distance himself from the instrument. While he taught himself some basics, he found no joy in the ivory keys when his mother was looking over his shoulder. It was the wind instruments that called him. A saxophone, gifted to him by his mother, first piqued his interest.

"This was your father's instrument," she said to him. "Maybe it'll be better for you than the piano."

Lee had very few interactions with his father. His mother and father had separated when Lee was a year old. His mother, Bliss, worked days at Standard Oil and played piano in night clubs after hours. One of the few things Lee knew about his father was that he was a patriot. He had enlisted in the Navy, left the service in 1940, but then reenlisted in 1941 after the attack on Pearl Harbor. Lee also knew that his father played the saxophone. So, as a young boy, Lee also began playing the saxophone, instructing himself on the instrument.

Lee grew, and so did his skills as a musician. As a teen, his mother married a contractor who built motels for Disneyland in southern California. In this new community, Lee would book plenty of gigs as a musician—both amateur and professional—while a freshman at Anaheim High School. In 1955, on the opening day of Disneyland, Lee began playing saxophone with the Keystone Cops Quartet in the park. His favorite music at the time was Dixieland.

At this point, Lee became proficient on most of the woodwind instruments. He once again took up piano and was now developing as a singer. As a musician, he had a diverse musical knowledge that allowed him to fit into almost any musical style. He was soon performing with several different groups. At night, he'd practice with the church choir before heading out to a club to play with a jazz or rock group. After his gig, he'd get out after last call, go home to sleep a couple of hours, and then wake up early for track practice at high school.

His busy schedule made his mother nervous. She was also out at all hours of the night playing gigs and didn't have the time or energy to keep an eye on Lee. To keep him safe, Lee was raised in Sacramento by his grandparents, Thomas and Edna Jackson.

There wasn't a lot to do back in the 1940s in Sacramento. When Lee wasn't working on the farm, he was practicing his music. During his time in high school, he struck up a friendship with his music teacher, Fred Cooper. Lee confessed to him that he was going to become a professional musician when he graduated. Fred said, "Then I'm going to teach you everything you need to know to survive when you're out there in the real world."

With Fred's encouragement, Lee volunteered to play timpani in his high-school orchestra. That's where Lee learned rhythm. Despite his shorter stature, he was also drum major of the marching band although the typical student in this role would otherwise be far taller. Lee continued to play in clubs in Sacramento with new jazz, pop, and rock musicians. His teacher, Fred, also gave him two years of music theory during his senior year in high school. Combined with his time in the choir at the First Baptist Church, Lee developed his own unique singing style. With these lessons and years of practice under his belt, Lee was prepared to take the world on. He packed up his '55 Chevrolet—a gift from his grandparents—and headed to Reno, Nevada.

Lee's first band and the one that followed him from Sacramento to Reno was called the Apollos. Almost immediately, he and his band were playing gigs at casinos throughout Nevada. Lee found himself singing more and more in these shows. Thanks to the time he had spent in the church choir, his voice had matured as a tenor with a Rhythm and Blues tone. But it was his time running track and

field that gave him the breath support and stamina he needed to do shows night after night.

He couldn't, however, rely solely on his voice to get gigs. In order to keep audiences and bookers interested, he had to have new material all the time. With the skills he had learned improvising in the clubs, he knew how to arrange music for many different styles and instruments. He composed day after day, and eventually, writing music became natural for Lee. Before long, he was arranging for major shows in Vegas. This helped him then secure gigs for his own band.

Lee's skill in arranging and his talent as a musician made him the de facto leader of his band. After a few years, he changed the name of his band to the Lee Greenwood Affair. Because Lee was taking such a leadership role creatively, he felt responsible for the group in business affairs as well. He started to learn the ins and outs of producing, managing, and marketing. Again, it was on-the-job training that taught him how to make his music into his business. He started scoping out other venues and locations for his band to perform, expanding their notoriety outside of casino shows.

In 1961, Lee permanently moved to Las Vegas. One of his first nights there, he was casing out the performance venues on the strip. At the time, the Thunderbird Hotel was the most happening spot on the strip for major acts. Lee quietly entered the casino and stood watching the group on stage from the entrance to the lounge. Performing that night was the Kirby Stone Four, a group that melded jazz, rock, and intricate harmonies into a unique sound. However, their bassist was what made an impression on Lee that night. The man holding the bass was future country star Kenny Rogers.

Lee would cross paths with Kenny many more times in his life, and in fact, it was this interaction that started to shift Lee's musical style. Up until this point, Lee's music was mostly considered

pop. He admired musicians of all sorts—including country singers and musicians—but it would be twenty years before he moved to Nashville. While his band and their popularity grew, he found himself in the company of more and more artists from Nashville.

One night in 1979, Lee was playing at the piano bar in the MGM Grand Hotel in Reno. Unbeknownst to him, the bass player for country music star Mel Tillis was in the audience. At this point, Lee had been playing in and around Nevada for almost twenty years. He was practically a staple in the casino scene. He had literally played almost every lounge on the strip. After his set that night in Reno, Mel's bass player came looking for Lee, but he had already left for the night. It wasn't until several nights later when Larry McFaden—the bassist and bandleader for Mel Tillis—found Lee. They became instant friends. Larry wanted to record a demo with Lee, but it had to be in Nashville.

Lee knew he had to take the jump. He had missed opportunities like this before. Years earlier, he was almost a part of the Young Rascals—the band that recorded the pop hit "Good Lovin" only weeks after Lee left New York. Lee and the guys that would form the Rascals were working with another act that had brought them together in Vegas. So, this time, when Larry McFaden offered him a chance to record in Nashville, he knew that it was time for a new chapter.

Country music was a different world for Lee. He'd grown up with Ray Charles, jazz, and rock. His voice had a distinctly R&B sound that went against the country twang. Moving to Nashville was a total leap of faith, but just like every other part of his life, he knew he had to learn on the fly. He spent many years recording in the studios with his new producer Jerry Crutchfield. Lee's opportunity to work with Jerry was yet another result of his entrepreneurial skill sets at play. While still in Vegas, Lee had seen that Jerry was the producer of a single hit record he loved called "Please

Come to Boston." Lee simply tracked him down in Nashville and called him at his office at MCA Music. He boldly asked for the opportunity to audition for him. As a result, Jerry boarded an airplane to Vegas to hear this new young talent. This relationship ultimately led to Jerry bringing Lee to the MCA Label. Crutchfield would become Lee's long-term producer in Nashville. Lee's first country hit, "It Turns Me Inside Out" was a smash: twenty-two weeks on the country charts. Suddenly, country fans had found a new voice on the radio. Lee's soulful voice leant a perfect timbre to the traditional sound of country music.

That was it for Lee. He would eventually record fourteen years with MCA completing two albums per year. With a sound that combined R&B vocals with traditional country instruments, Lee Greenwood started to sell more and more records. Lee wrote many of the songs on his albums. When he wasn't recording, he was touring—almost three hundred days a year for the first three years.

While never shy to perform, he certainly had to adjust to these new audiences. Through touring, Lee learned that each audience was different—composed of different individuals with different tastes. He made it his mission to personally connect with each audience. He wanted to leave them with an unforgettable experience. The challenge to connect to them was great, but thanks to his energy and stamina—from years as an athlete—he was able to win the crowd. Opening for every act in Nashville, he learned that it wasn't just the performance but the autographs after the show that won the fans.

Touring was tough. Every night he was in a new city playing for thousands. It was, however, the first time that this West Coast boy had seen all his country had to offer. The amazing landscapes of the Appalachian trail and the raging currents of the Mississippi inspired him. He was charmed by the midwestern politeness of the country fans in Ohio and Pennsylvania, just as much as the down-home

comfort of Texas. Lee learned firsthand the beauty of the American experience and the countless ways it exists throughout the U.S.A. He truly was proud to be an American.

So he did what he always did when he felt inspired—he wrote a song. To Lee, America was both his home and an ideal of greatness. He had an immense appreciation for those who defended that ideal, and he wanted to make sure they were also remembered. For Lee, his father was one of those people. He penned the line *"I won't forget the ones who died who gave that right to me"* for the people like his dad—both past and present.

Lee's story is an embodiment of the entrepreneurial spirit that is unique to America. As a child, he had next to nothing. But he never let that stop him. He pulled himself up through determination and discipline. While his song is perhaps one of the most quintessential expressions of America that we have, Lee's own life stands as a monument to American ideals, passions, and dreams.

## ARTIST-ENTREPRENEUR TAKEAWAYS

Lee's journey as a musician had many twists and turns, from California to Nevada and Tennessee, to all over the United States. It would be easy for a young man of less conviction to get lost among the noise. Lee, however, knew he had to remain steadfast. That was the only way to succeed. His focus was sharpened through his faith in opportunity, his energy and drive, and his self-discipline. These three qualities are part of what made him a successful musician and businessman.

From a very young age, Lee knew he had to take opportunities where he could get them. Three gigs a week along with choir,

band, and track practice in high school would have been too much for most kids, but it helped teach him how to multitask. It also, however, taught him how to spot an ideal opportunity for growth and change. He believed that opportunities would present themselves to grow his skills and his network, which is what empowered him to take chances. When he was approached by Larry McFaden to start recording in Nashville, he saw it as a challenge and a next step in his career. Where can you find your own personal opportunities for growth? How are you stretching your network so that those opportunities are more likely to come your way?

Another quality that kept Lee's eyes on the prize was his drive and his pursuit of his art. Lee was never interested in drugs or alcohol. In fact, his ability to ignore those things in a wild atmosphere like Las Vegas helped him rise to the top. Complete and total sobriety is not necessary for every art entrepreneur, but it is important to understand when indulgences can turn into distractions. Are there substances that you use that keep you from achieving your artistic goals? How can you eliminate those distractions from your life so you can work toward being a better art entrepreneur?

Lastly, Lee had an incredible amount of self-discipline. At almost every phase of his life, Lee was learning on the job. He gained great business acumen by taking the lead with his band during their early years in Las Vegas. He completely changed his style in Nashville simply by listening and adapting. And it's hard to ignore that he taught himself multiple instruments through practice and perseverance alone. Lee's commitment to becoming a more well-rounded musician and art entrepreneur helped put him in the right place at the right time. How are you challenging yourself? Can you put more time into bettering your skills and talents?

Ultimately, there is one last part of Lee's success that is crucial to art entrepreneurs—chance. Many of the opportunities that came

Lee's way were unplanned collisions with other artists that led to great things, just like the story that started off this chapter. Chance, however, is the product of creative thinking, courage, and strategy. When Lee had three hours to kill in Los Angeles, he didn't spend it at a bar. He was determined to seek out a way to get in front of one of the most powerful executives in music at the time. But if he hadn't gone to Azoff's house that night, we might never have our second anthem—"God Bless the U.S.A."

Marin Alsop

# Marin Alsop

## *Conducting Dedication*

There's a stillness in the air of the Joseph Meyerhoff Symphony Hall. About two or three dozen musicians quietly prepare themselves on the stage as the audience files into their seats. There's some chatter from performers and spectators alike, but eventually they all settle into a quiet anticipation. A cellist repositions herself on her chair. The flutist double checks his music. An audience member coughs. Then, as if by clockwork, the oboist stands and plays a long A-note. A wave of string instruments tuning to that note rises into the hall. Then silence. Again, the oboist plays the same note and the wind instruments follow suit. The orchestra is in tune.

From stage left, the conductor enters wearing a black blazer with red poking out from the sleeves. She crosses in front of the orchestra, steps up onto the platform, and bows to the audience. After taking in their applause, she turns her attention to the orchestra and lifts her baton. With that movement, Marin Alsop begins to conduct her first concert as music director for the Baltimore Symphony Orchestra.

This is by no means Marin's first time holding a baton. Throughout her career, she has guest conducted for other orchestras across the world, in Glasgow, Los Angeles, and Tokyo. This is, however, her first time holding such a prominent role in one of America's biggest symphonies. The pressure is on, but Marin is determined to make her debut in Baltimore a success—to take her place at the table and fully realize the ambition that has defined her entire career.

Marin was destined for music. She grew up in a home whose every room was filled with melody. Her father, Lamar Alsop, was concertmaster for the New York City Ballet for thirty years, but also played saxophone, clarinet, and flute for Fred Waring's big band. Marin's mother, Ruth Alsop, was a Radio City Music Hall cellist who also worked a great deal as a chamber musician. Marin was born on October 16, 1956, and started playing violin at the age of five. Even their dog sang when the three of them played together.

It was just the three of them in their cozy home in New York, but there were always musicians hanging about, usually chatting about music. From a very young age, Marin began to develop a wide-ranging taste in music: swing, big band, Bach—she loved it all.

While it was a centerpiece of their home, music wasn't the only passion for Marin and her family. Marin's mother weaved baskets and crafted pottery (in fact, most of Marin's dishware when she was young was handcrafted by her mom), and her dad had a knack for flipping houses. Whenever he had two dimes to rub together, he'd run off and buy the latest fixer-upper to make it livable for the next family. Marin's parents taught her the Alsop family motto: you'd better have a lot of dreams because there is no guarantee that they'll all come true. This instilled in young Marin a sense of constantly learning and incorporating ideas from others. The ability to bring ideas to fruition often requires a level of "scrappy" productivity to realize efforts that have either previously failed or never been attempted.

And that's just how she approached the world. Marin took inspiration from any form of art she encountered and used it to better herself as a musician and as a creator. She watched her mother mold clay into pots. She'd hold nails for her father while he replaced the frame of a window in a decrepit house. She listened and danced as

musicians of all stripes paraded through her house. Marin always knew that she wanted to be a musician, but a trip to the symphony when she was nine years old would be the catalyst that would lead her to pick up the baton.

Marin's father took her to a symphony performance in New York City—a performance conducted by the great Leonard Bernstein. Marin watched in awe as the Maestro of Maestros took the stage, lifted his baton as if it were a wand, and began to emanate pure magic from his fingertips. With dramatic, expressive motions, he commanded the attention of the orchestra and the audience alike. His entire body swayed and spun as he led his instrumentalists in movement after movement.

Up until this point, Marin had thought conductors were stuffy old men with slick hair and rusty door hinges for joints. But seeing the way that Bernstein led an orchestra, she was inspired. His style was so passionate and fluid. Conducting didn't need to be rigid, she realized; it could make a person a conduit for the music, letting them convey their vision of a symphony to an audience. It was at that moment that Marin knew she wanted to be a conductor. This leadership role would provide her the opportunity to not only bring forward her artistic vision but be collaborative so that it could be achieved through others.

But at that time, there were almost no female conductors. When she said she wanted to be a conductor, her teachers would either laugh or try to console her. There had never been a female conductor, they said, and there probably never would be. The Alsops, however, were more supportive of their daughter. It was no one's business to tell Marin what she could or couldn't do. They encouraged her to pursue her interest in the violin so that she could better understand the workings of the orchestra.

As she grew up, Marin continued to study and practice, slowly transforming from a young novice to a mature, capable violinist. After graduating from Yale University, she went to study violin at Juilliard, where she obtained her master's—although she was

denied admission to Juilliard's conducting program. Juilliard's was one of only a few such programs in existence, and the competition to get into them was intense.

As soon as Marin left Juilliard, she began booking violin gigs wherever she could. While freelancing was helping her make ends meet, it wasn't fulfilling. She began to crave something she could call her own, some way she could make her mark. Remembering her dad's time playing big band music, she developed an interest in jazz that by 1981 inspired her to form String Fever, a ten-piece swing string orchestra. A critical component of her work at this point was moving beyond ideas to physically organizing people into an ensemble, a functioning structure with the facility to re- alize those ideas. Marin took her creativity and transformed it into community impact through planning, organizing, and articulating her vision to others. She knew that one of the most important skills for an entrepreneur was knowing how to delegate.

With String Fever, Marin got a taste for leading a group of in- strumentalists, but she knew that she wanted to take on a stronger role. She kept thinking about Bernstein's emphatic conducting style, and the beautiful sounds he evoked from the orchestra. Marin could feel her fingers itching to conduct, so, after three years with String Fever, she moved on to her next project—Concordia, an or- chestra dedicated to exploring twentieth-century music. Concordia frequently bent the genre of orchestral music: in 1993 at Lincoln Center they debuted *Too Hot to Handel*, a gospel, jazz, and rock rendition of Handel's *Messiah*.

Both String Fever and Concordia are still performing to this day. Marin has moved on from both groups, but these ensembles carry the spirit that their founder imbued in them from day one.

In the summer of 1985, Marin packed up her apartment in New York and moved to Hartford, Connecticut, after being accepted

to the Conductor's Institute at the Hartt School, a performing arts conservatory at the University of Hartford. She was slated to work with Harold Farberman, famed conductor of the Oakland Symphony Orchestra. Marin was ready to develop the skills she needed to become the incredible conductor she was meant to be. With a full course of study with Farberman and other highly respected conductors, she had everything she could need. However, there was one thing missing at the Hartt School: other women.

Marin was surrounded by men while she was studying conducting. It was still not fashionable for a woman to conduct an orchestra—but that didn't stop her. Marin never let her gender get in her way, and if she got a piece of feedback that seemed harsh, she never tied it to the fact that she was a woman. "I would attribute some of my success to the fact that I have never interpreted any rejections as gender-based, even if I could have done so," she says. "This enabled me to use such rejection as an opportunity to improve myself by working harder, listening to criticism, and developing even more perseverance!"[1]

And the young conductor had something that many other students didn't have: drive. She knew that if she was to succeed in this male-dominated world, she'd need to be twice as good as her colleagues. This meant she had to eliminate all nonessential gestures; a man could raise his pinky on a baton, but if Marin had done so, she would have been criticized for looking too feminine. And yet, on the other hand, being too forceful was also a problem. "When a woman makes a gesture, the same gesture as a man, it's interpreted entirely differently," she once told an interviewer. "The thing I struggled with the most was getting a big sound from the brass, because you really have to be strong—but if you're too strong, you're a bitch."[2] She composed herself with the same discipline she used to marshal her orchestra.

After she completed her course of study with Farberman, Marin began to seek out conducting and music director positions. She was still involved with String Fever and Concordia, but now

she was trying to rebrand herself as a conductor. Over a couple of years, she booked a few of these gigs in cities across the country—the Eugene Symphony Orchestra, the Tanglewood Music Festival in Massachusetts, among others. Marin's dedication was paying off.

It was while working at the Tanglewood Music Festival in 1988 that Marin got her big break—from someone who had been her idol since she was nine years old. She was picked to work with Leonard Bernstein.

Marin was chosen over hundreds of other conductors, most of them men, and she dedicated herself in earnest to soaking up all the knowledge that her hero had to share. She became Bernstein's protégé, and throughout all her rehearsals and workshops, LB (as she called him) would be there next to her.

Bernstein imparted to Marin a host of lessons, the most important of which was to respect the composer and to tell the story. To him, the composer was the most important part of any orchestra, and it was the conductor's job to uncover the creator's true intent. In order to do this, every time he approached a piece of music, he'd treat it like it was his first time reading it. He'd spend hours poring over the score with fresh eyes, searching for clues from the creator. Inevitably, he'd discover something new. To him, every composer was trying to say something about themselves in every composition. As the conductor, he felt it was his job to tell as much of that story as possible, and he'd become frustrated if the orchestra didn't understand the story they were playing. At one of Bernstein's rehearsals that Marin attended, the gray-haired conductor put his baton down with a heavy sigh of exhaustion. "Must I tell you the story of this Haydn symphony?" the conductor said. He then captivated their attention with a vivid story of the origin of the piece.

These lessons shaped Marin's approach to music. She began to understand that excellent performances were produced by a synthesis of conductor, story, and creator. She came to exemplify key aspects of leadership that she learned through this prism of

conducting. Ultimately you lead by working for others, by understanding their roles in the greater context, by being interested in and empathetic toward their needs and motivations, and ultimately by inspiring through your actions rather than mere words.

Over the next few years, Marin was rarely apart from LB. After a quick tour as the associate conductor of the Richmond Symphony Orchestra, she accompanied him to Japan, where she helped her hero establish the Pacific Music Festival in Sapporo.

Bernstein's mentorship opened doors for Marin. In 1993 she was named the music director of the Colorado Symphony Orchestra, which won several awards under her direction. She was also principal conductor of the Bournemouth Orchestra from 2002 to 2008—the first woman to hold that position. It was Marin's 2005 selection as conductor for the Baltimore Symphony Orchestra, however, that would embroil her in public controversy.

The search committee that had been tasked with selecting a new conductor included several members of the orchestra itself, and when these musicians heard that the search was narrowing down and that Marin was the leading candidate, they were not happy. They issued a statement saying that "ending the search process now, before [they were] sure that the best candidate had been found, would be a disservice to the patrons of [Baltimore Symphony Orchestra]."[3] Some of them felt that Marin lacked the technical prowess to be their conductor—that she ignored problems because she either couldn't hear them or didn't know how to fix them. The very people from whom Marin drew her authority were turning on her.

Marin was blindsided. She had no idea why an orchestra with which she'd had so many positive experiences seemed to be unwilling to work with her. She'd performed with them as a guest conductor several times already, and those performances had been praised both by musicians and by audiences.

Despite this rebellion, the board members who had selected her were determined. They knew Marin was the perfect choice to

infuse new life into the BSO, and with their full support, Marin picked up the baton.

Marin knew she couldn't allow an artistic disagreement ruin her relationship with her musicians so she addressed them directly and gave a short speech. "Listen," she said, "I don't know how this got to this place, but I need to know that we're a team. It'll be hard, [but] I can put this behind us if you can." After she'd said her piece, Marin told her players that she would step out of the room so that they could speak privately—but she wasn't even a dozen paces away when they called her back. They were ready to work.

Since Marin's appointment to the BSO, her influence on orchestral music has spread across the globe. She continues to serve as the principal conductor and music director of the BSO, and in 2012, she was appointed to those same positions by the São Paulo Symphony Orchestra. Marin never says no and never backs down from a challenge—even if it looks like the odds are stacked against her.

When Marin was first starting out, she was one of very few women in the conducting game. Since then she has paved the way for female conductors such as Xian Zhang, Simone Young, and Susanna Mälkki to thrive in a world that was once just for men. Marin's determination and confidence made her the Maestra she was destined to be. Other art entrepreneurs would do well to emulate these qualities. With a heart full of passion and a head full of determination, Marin Alsop has changed the face of orchestral music in America and around the world. Her strong conducting technique is mirrored by her strong sense of self. And it doesn't look like she's putting the baton down anytime soon.

## ARTIST-ENTREPRENEUR TAKEAWAYS

Demonstrate grit. To be a vanguard, you need to have an uncommon level of determination. Marin's dedication to bettering herself not only made her the best conductor she could be, but also turned her into a trailblazer. This dedication was embodied by her fighting spirit: when someone told her that she couldn't do something, she just took that as a challenge. Marin's confidence allowed her talent to shine. No matter what she did, she always had conviction in her own ability. People often refer to this combination of confidence, determination, perseverance, and persistence as simply grit. Where can you dedicate more of yourself in your endeavors? What about your own art do you like? Can you see your own work as a valuable contribution to your field? How can you embody a greater level of grit in your life?

Collaborate. Before Marin got to the Baltimore Symphony Orchestra or became a MacArthur Genius Fellow, she was creating opportunities for herself whenever she could. Her diverse group of collaborators helped her develop her skills. In String Fever and Concordia, she had a laboratory to try out new ideas that excited her. And in her time with the Colorado Symphony Orchestra, she was able to flex her conducting muscles in a way that a larger symphony might not have been comfortable with. Do you have a group of friends that you collaborate well with? How can you utilize them to better yourself and create opportunities for your art?

Damon Gupton

# Damon Gupton

## An Artistic Nomad

Damon Gupton was born in Detroit, Michigan, in 1973. The 1970s and 1980s were the height of the big Hollywood blockbuster. Movies like *Jaws*, *Close Encounters of the Third Kind*, *Star Wars*, and *Superman* were premiering almost every month. In neighborhoods like the one Damon grew up, theaters were plastered with these movie posters. Damon loved the movies and the way the epic stories of these heroes and villains unfolded on the screen.

When Damon was five years old, his mother came home from shopping at the local Kmart. Out of the bag, she pulled the soundtrack to the *Superman* movie that Damon had seen months before. But when his mom put the record on, he didn't hear any of Superman, Lois Lane, or Lex Luthor. Instead, brass horns shouted out a march that was answered by delicate woodwinds and harps. Drums beat out a tattoo, eventually giving way to an orchestra of strings carrying a melody of hope and bravery. Damon was perplexed.

This record purported to be *Superman*, but it was just instruments. As he listened on, however, he realized that this was the music playing underneath the movie—the soundtrack. It was the flourishes and sweeps that made Superman's heroic actions seem the more valiant and daring.

Damon spent hours listening to this soundtrack. He poured over the record jacket, reading every name involved with the orchestration. That was how Damon first learned about John Williams and his music. Damon became obsessed with the way

that an orchestrated melody could evoke a feeling in him almost like a performance on-screen.

Then a couple years later, he saw John Williams direct the Boston Pops Orchestra on TV. He was amazed at how a sweep of his arm could summon up an incredible sound or a flick of his pinky could make timpani ring out. Damon was transfixed. He carried that fascination with him for a while. Eventually, he went to the library to take out a book on conducting. He wanted to be more like his legend and wanted to explore his curiosity. Even as a young person, he found the process to be interesting, fun, and attractive.

A bit later in life, Damon would sit in his room devouring records. Eventually, when the movies became more accessible, he would listen to soundtracks with that same sense of fascination, weaving stories and allowing his mind to wander. Damon's love for music and story would take him on a lifelong journey, a windy path with undefined outcomes at every bend. It would be an adventure, and it remains one to this day.

It was through the soundtrack of blockbuster films that Damon got his first taste of music. It was a Golden Age of film music, and he wanted to listen to all of it. After the *Superman* record, he bought soundtrack after soundtrack. That drive to listen to scores came from a desire, that innate sense of thrill and exploration that only music could offer at that time. Damon was developing a passion, not yet necessarily driven by the need to study, but rather intellectual and emotional curiosity in this medium. And the process was getting more satisfying.

In high school, he joined the band in order to learn music practically. While there, he started to listen to the great masters of classical music: Tchaikovsky, Beethoven, and others. Challenged and encouraged by his teachers, he began thinking about where

Williams drew inspiration. He began looking beyond Williams and wonder from where some of the composer's own sensibilities came and how his musical language was influenced by those before him. Parallel to his fascination with music and Williams in particular, Damon remained curious and interested in other things. He had and continued to have an open, nimble mind and an attraction toward creative exploration.

While Damon loved the scores of these movies, the films themselves enthralled him. He enjoyed watching esteemed actors play their parts. He would get a thrill from watching a talented performer playing out a difficult scene. He would find true beauty in another, as he saw them going through a catharsis. For Damon, the journey of the Star Wars Saga, Spike Lee movies, seeing Avery Brooks on stage playing Paul Robeson were all poignant experiences. To explore this further, his journey took him to participate in plays, often after his band rehearsals.

Interestingly, Damon's mother was an outstanding public speaker and passed on that gift to her son. Damon gave speeches in church and youth groups. He was also in forensics class in high school, winning national titles for dramatic and oral interpretations. He was fortunate to have this affinity and aptitude for expression and enjoyed the experience of channeling those gifts, even without always knowing where his path might ultimately lead him.

When he began attending acting classes, Damon loved impersonating those creative giants he revered, like James Earl Jones and others. In doing so, he was searching and discovering his own voice. Damon developed real talent as an actor, performing in more plays for his high school each year. But as college approached, Damon did make a choice. He was to pursue music and specifically music education. His mother did advise him to select education and not purely a performance degree, so as to have greater options for his career post college. At this juncture, Damon was genuinely excited to embark on the journey to study music at such a prestigious school: the University of Michigan.

In college, Damon immersed himself completely in his love of music, while participating in occasional plays. His clarity of vision and focus were clear. Classes and independent music ensembles fed his creative curiosity. Before long, however, Damon was yearning for additional or different expression. He would take opportunities to reconnect with his other love: the theater and acting in general.

Curiously, as he discovered more and more of his passion for conducting, he was not accepted into the graduate conducting degree. He only applied to Michigan, as he thought it was the only place he wanted to be. It did not, however, stop him in any way from the pursuit of his passion. Beyond that, to this day, he is a sought-after guest conductor, having conducted several major ones throughout his career and held esteemed posts during various times.

Rushing from orchestra performance to rehearsal, he had a full calendar right from the start. It was not simple combining twenty-credit-hour loads, practicing, and learning plays. However, the experience equipped him with the skill sets to manage a varied portfolio life and the discipline required to do so meaningfully. As a music student, he assembled and led ensembles of his peers to create both traditional programs and those exploring new and contemporary music. His involvement in theater was certainly secondary, but it did serve as a different but deeply satisfying avenue for expression. Beyond expression, it was a release of energy and, at times, anger or frustration. He recalls it today as a cathartic experience.

Damon loved this duality in his life and welcomed each aspect of his creativity with renewed energy and hunger. Each medium did offer a different palette, a different avenue for distinctive aspects of his persona to come alive. As a consummate artist, Damon did strive, despite this duality, to give each medium his 100 percent. He did so by focusing and being in the moment, mentally and emotionally.

Damon allowed his paths to run concurrently and found it stimulating. To satisfy his voracious appetite for learning, he took several additional semesters in music and drama classes, even after being rejected from Michigan's graduate degree in conducting. He

then auditioned for Juilliard, with the guidance of some of his professors at Michigan. He was accepted to train in acting with the Drama School at Juilliard. Just like the nomad he was, the decision to go to Juilliard was a simple one—it was Damon putting one foot in front of the other. During his studies as an actor, Damon recalls a particular experience back during his undergraduate years: seeing Robert De Niro in *Raging Bull*. The way De Niro held the screen struck Damon. He wanted to learn how he could do something like that—how he could evoke that kind of reaction in a person.

While Damon was shy, he drew on his inspiration and allowed his training to be deeply personal and connected to the ultimate reasons why it felt like the right pursuit.

Post his studies at Juilliard, his acting career already met with some success with TV shows, plays, as well as movies. While he was pounding the pavement trying to book acting gigs in the early 2000s, he felt a bit tired, and as the summer hiatus approached, another opportunity came together. A girlfriend told him about the Aspen Music Festival's Conducting Program. As a way to add a spark and feed the other side of his creativity again, Damon applied and was accepted to the conducting program at Aspen, where he would truly develop invaluable skills as a conductor for the ensuing several summers.

Through this amalgamation of training from the University of Michigan, Juilliard, and Aspen, Damon had the skills and the talent to fully establish and craft his unique artistic career. In the performance world, there had been many actor hyphen combinations—"actor-dancer," "actor-singer," or "actor-musician" for example. But Damon was none of those. He was something very few people had seen before. He was an "actor-conductor." Damon had never met another actor-conductor. He had no one to look to for guidance. He had to figure it out on his own.

As he walked his journey, Damon continued to switch in and out of both of his skill sets. Amazingly, he was successful in both, but he would still need the breaks that he took in college to refresh

his artistic spirit. After finishing an exhausting run of on- and off-Broadway appearances, for example, he'd be glad to land a symphony gig in a major metropolitan area. This switching ensured that he could bring passion to his work, no matter the medium.

Unsurprisingly, this fervor paid off. For his 2012 performance in Broadway's *Clybourne Park*, he received an AUDELCO nomination for Best Supporting Actor. And three years before that, he led the Sphinx Virtuosi (then Sphinx Chamber Orchestra) on a cross-country tour, including performances at Carnegie Hall—for which he received rave reviews. Accolades were pouring in for Damon. Some audiences loved him no matter the side of the stage on which he found himself.

Switching back and forth benefited Damon, but it wasn't without its struggles. The flexibility in his career kept him curious, but working night after night could cause burnout. Being as busy as he was, he risked losing the meaning behind his work. He had to learn how to get very quiet to listen to his own impulses. Despite the praise, he remained humble and even describes the feeling as being unsure that he was able to afford enough time to both disciplines.

Damon was called upon for a variety of different conducting opportunities. He embraced each to its fullest, affording these opportunities all that he had to give creatively and emotionally at any given time. Two distinctive occasions imprinted upon him as important lessons to share. On one particular occasion, Damon was asked to conduct a particularly difficult concerto for an orchestra. At the time, his star was on the rise. He appreciated the praise he received. He always prepared as well as he could, especially given his overall workload. In fact, this period in his life really marked another intentional priority on music, with almost no acting. This concert came at a time when Damon found himself swamped with many responsibilities and also preparing for a conducting competition of which he was the co-winner. Accepting this challenge as a guest conductor was biting off more than he could chew.

He started off the work comfortably and confidently, in the context of an overall successful delivery of other repertoire on the program. The orchestra was with him, and he felt the piece connected with the audience. The composition, however, had much repetitive material, with challenging passagework that accelerated quickly. Within the coda of the work, Damon looked down at his score and realized that he had dropped a bar. And then the piece unraveled. Soloists missed some of their cues; certain sections of the orchestra found themselves in different tempi. While still leading and finishing with conviction, Damon felt that he had failed. He felt his stomach tense up.

The truth was that the performance simply came at a dense time, full of commitments and a high level of artistic output in his regular conducting position. The simple lesson was not saying yes to more than what is humanly possible. One mustn't lose the hunger and lust for challenge and opportunity: Damon reflected that this one simply did not permit him to prepare and deliver his absolute best, something he knew he would have otherwise done, under different circumstances.

Another earlier lesson he recalls illustrates the unfortunate reality of human dynamics, particularly in the context of being a young, high-achieving artist, driven to succeed. The road to success is certainly paved with hard work, perfectly mixed with sensitivity, preparation, and opportunity. However, at times, those do not present themselves in a perfect ratio. During one of the rehearsals as an assistant conductor of a major orchestra, Damon found himself at an unexpected impasse: one of the members of the orchestra displayed unprovoked, unexpected hostility toward the young conductor. Without assigning categorical indictment, Damon's experience, while unnecessarily negative, inspired the advice to be resilient: one cannot guarantee themselves a path perfectly appointed with constant good-doers and well wishes. One does encounter exceptions and, regardless of the circumstances, we are to respond, as best we can. In this case, endurance, flexibility,

and forgiveness came into play. He had a physical reaction to the adversity, which caused him to get ill minutes prior to the rehearsal. The unfortunate reality was the convergence of negative emotions and the immediacy of the task at hand. While jarring, however, Damon does not recall being disheartened for long. Perhaps partly because he knew he could not afford to be: he owed it to his own career and his creative voice to keep going. And that he certainly did, conducting dozens of performances with an array of orchestras. Something Damon does to this day: he moved forward.

Damon landed recurring TV roles on several shows including *Suits*, *Bates Motel*, and *Empire*. He was a regular on *The Player*. Damon's TV résumé was growing. While he remains self-critical to this day, always moving forward, taking opportunities, and welcoming challenges ultimately gave him the confidence necessary to never lose sight of the path. He began to listen to that small voice inside him that gave him the direction. He learned that each day, he would have to get up and tackle what needed to be done.

In 2016, Damon was cast as a series regular on *Criminal Minds*, one of CBS's most popular procedural dramas. While he had enjoyed the success of a number of acclaimed productions and successful runs with five television series prior, *Criminal Minds* was simply the most visible work. As an actor, he credits many other experiences as significant and life-changing, though, in many ways, that illustrates the difference in perspectives and perceptions between the audience, the beholder, and the artist himself. In many ways, this role may have been the most recognizable. It also became an opportunity that was cut short, and those do not come without angst. Damon spent six months shooting fifteen episodes, and three weeks prior to returning, the news came that they were not running with his option. As an actor, he was being eliminated. Losing a lucrative job, he did take this one personally, as he had never been fired prior to this. It was a stressful time that felt like a gut punch. With this lesson, however, Damon stressed the importance of not romanticizing success and an oft-unrealistic

charge to always be able to weather adversity. There are, indeed, uphill battles to be fought. Being an artist does come with frustrations, a sense of loss and pain. Hard work does not always ensure a smooth outcome or consistent success. The biggest part of victory is the process of earning it and knowing that ultimately it is rarely fully attained. The lack of finality is not failure; it is the heart of the journey. Again, it was time to put one foot in front of another, and a month later, a role on the CW's *Black Lightning* was offered to him. He accepted.

A year and half into his job on *Black Lightning*, Damon returned to that difficult piece he conducted. He took a breath and told himself he could do it. While digging into a challenging circumstance does not guarantee success, persistence itself can get one the closest to realizing the formula. Here the lesson was to move forward and know that as an artist, you are capable of walking the same path with a different routing. Creative problem solving is a worthwhile exploration and a more positive alternative to giving up and having a categorically closed opinion on something.

Damon had no idea he would be as successful as he is today. When he was in undergrad, he assumed he'd be a music teacher somewhere in Detroit—teaching young kids music performance. Today, he continues to act and conduct. He is a series regular on *Black Lightning*. He conducts whenever the chance comes along. But he knows nothing is certain. That's why every day he takes one step at a time.

## ARTIST-ENTREPRENEUR TAKEAWAYS

As a kid, Damon discovered that his name spelled backward is nomad, the term for someone who is constantly wandering. A nomad is a person who never settles and is always on the lookout.

For Damon, these were admirable qualities. He wanted to become an artistic nomad—always hunting, always seeking out new things. Throughout his artistic journey, he is constantly roaming between two areas of expertise: acting and music. To each of these, he brings dedication, inner focus, and a fresh perspective that can only come from being a nomad, one with an open heart and a flexible mind.

As we've learned, Damon has two great loves. However, it could be said that they are rooted in one thing—creating and sharing channels for expression. Whether it is in his acting or conducting work, Damon is driven to share his feelings, his quest, by expressing it to others. His vision is so strong that he sought out post-graduate training to keep his skill sharp. Even as a child, his deep curiosity led him to teach himself the most he could about conducting—simply by taking books out of the library. And as a professional, he found that when he digs in his heels and gets dirty, he creates the best work. What is your art dedicated to? What ultimately drives you to continue to make it? What are you trying to do with your art and for whom? When you've sorted that out, you might find it easier to create without worrying about the future.

During various points of his career, Damon felt a lot of pressure to make choices about tomorrow. Where he should study or what he should focus on were constant worries of the outside world. Through ups and downs, however, Damon realized that the only opinion he could trust was his own inner voice. Damon had to spend a lot of time with himself to hear his impulses, but once he discovered them, he couldn't take any other answer. It wasn't just unsolicited advice, however, that could drown out his inner voice. Praise and protests alike could be a distraction. They are also motivation and education. To this day, he examines and questions what drives and inspires him. What first inspired you to start creating your art? How can you keep reminding yourself of your own impulse to create throughout a day?

While it might seem hectic, Damon thrived on having multiple gigs in the air at any given time. He felt that having these two

passions allowed him to tap into different sides of his creativity and find a fresh channel for expression. Time away gave him a new perspective on both disciplines whenever he returned to them. Often combining both meant developing the ability to think on multiple levels, while giving his entire creative self, being present. While you might not have two artistic areas of interest, what are ways that you can step back from a problem you're having to get perspective? How can you develop other artistic practices to give yourself a diverse viewpoint that distinguishes you from others?

Damon's path is a wandering one. It takes many twists and turns that your own path might never take. But it is unique to him. While he was never absolutely sure where he was going, he was kind enough to himself to know that not knowing was OK. All he had to do was go forward, even if going forward was scary. Because after all, nothing is worth doing if it doesn't scare you a little bit.

Chip Davis

# Chip Davis

## *Tinkering with a Steamroller*

Chip Davis enjoyed working with his hands. He was a tinkerer. When he was in high school, he appreciated taking apart appliances and putting them back together. He'd construct shortwave radios to communicate with his friends across their backyards. Chip would fill his bedroom in Sylvania, Ohio, with screws and wires that had been meticulously cut out of machines to be repurposed into something fantastic in the future. One day, he hoped to be an electrical engineer.

While he loved turning a screw, Chip had another passion: music. He'd started learning the piano as quick as his parents could get him up on the bench. His parents and grandparents were all musicians, so he was surrounded by instruments from a very early age. His engineering prowess made it possible for him to fix his parents' instruments when they gave out. Before long, he was fixing instruments for his high-school orchestra. That's where Chip's journey with music really began.

He'd fix the brass, tune the stringed instruments, and mend anything else that was making music flat. Before long, he was playing the bassoon in the reed section. That was where he met a friend by the name of Dale. As fellow tinkerers, Dale and Chip decided to go into business together. They wanted to create a product that would help out all their fellow woodwind instrumentalists.

They founded Chip and Dale Reed Manufacturers. They carved new reeds for wind instruments and then sold them at local music shops. Chip and Dale went around the state of Wisconsin to

music shops to sell these new reeds. Chip wanted to make sure that the reeds were affordable as well, so he included instructions on how to customize the reed to specific instruments.

Chip's first entrepreneurial venture, while small, was indicative of his dedication and determination. He loved music so he fearlessly pushed himself into it with no thought of failure. It pushed him to become one of the most recognizable country music songwriters before he turned thirty. This determination eventually would lead him to create his own music machine: the Mannheim Steamroller. While the Mannheim Steamroller wasn't an actual machine but a new-age orchestra, it contained all the intricacies and details that Chip was familiar tinkering with.

Chip grew up in Sylvania, Ohio. Almost everyone in his family was a musician. His father was a high-school music teacher, and his mother played the trombone. Both of his grandparents played the piano and began instructing him on the piano as early as four years old. Even from an early age, Chip was interested in the way music was written and arranged. Thanks to the instruction of his family, he knew rudimentary basics of arrangement as early as six years old. That was when he wrote his first piece—a four-part composition praising his dog.

After he graduated from high school, his love of the bassoon took him to the University of Michigan where he enrolled in the School of Music. There he studied music education and continued his love of the reed instrument. One thing that he didn't appreciate about his education, however, was how rigid it was. According to his professors, he was only to take the classes that would be beneficial to him as a bassoon player or as a teacher. Chip craved more from music. He knew he couldn't just be stuck fiddling with the same tune.

Chip wanted to learn everything there was to know about music, but he didn't want to catch flak from his instructors. In

secret, he'd take courses in composition to learn music theory more in depth. He'd also take voice classes so that he could better understand how his body was his own instrument. By taking these classes, he expanded his own expertise and gained new perspectives on his musicianship. He would continue to take classes in voice and composing throughout his twenties.

One year, Chip took a voice workshop with Norman Luboff, an esteemed arranger and choir director. The Norman Luboff Choir was famous at the time and toured all over America singing American classics and holiday favorites. Landing a spot in the choir was a sweet gig. Many singers were eager to tour with Mr. Luboff. After the workshop was done, Chip went up to the choir director and asked him if there were any open positions in his choir. Luboff responded that there were and invited Chip to New York to audition. A year later, Chip was touring with Norman Luboff and his incredible choir.

Chip spent the next couple of years traveling and singing with the Norman Luboff Choir. It was one of his first experiences working with a large professional music organization. He was amazed how Norman coordinated and managed an incredible amount of people at once. He'd spent time with other orchestras in school but didn't realize the managerial expertise that was needed in order to bring a massive show like the Norman Luboff Choir to stage.

While he was touring with the choir, Norman Luboff noticed that Chip had talent in arranging and composing music. He invited Chip to write some pieces for his publishing company. Chip started working on standards that would get bought out by regional orchestras around the country. Around that time, he met Mel Olson at one of Norman's workshops. Mel wanted Chip to come out and do a workshop with his chorus out in Omaha. Chip obliged.

Chip's one stop in Omaha, however, turned into an extended visit. Before long, he was music director for the Talk of the Town Dinner Theatre's production of *Hair*. In Omaha, he found stability

and structure. He liked that. He found solace in the fact that he could sleep in the same bed night after night without having to wake up and go. But he needed a job. He couldn't support himself with just a dinner theater gig. Chip applied for a jingle writer position at an advertisement agency and was hired almost immediately.

Writing jingles was a good gig for young Chip. He'd been writing music since he was a child, and now it was time to put those hard-earned compositional skills to work. Every day, he'd spend hours in the studio writing advertisements for businesses hoping to catch their customers by the ears. Chip's recording studio became like his laboratory. He'd use classical composition forms and styles and apply them to modern short tunes. He'd toy with melodies to get them just right for his clients.

One of Chip's biggest clients was the Old Home Bread Company. For these ads, he partnered with a writer, Bill Fries, to create a character that became emblematic of Old Home's brand. C. W. McCall was a semi-truck driver that traveled across the Midwest to deliver Old Home Bread products to cafés and fill-up stations. The trucker would sing about his adventures delivering Old Home's bread and the people he met on the way. C. W.'s song styling would blend country and bluegrass sounds into digestible sixty-second ditties that captivated audiences.

The campaign was a hit. Old Home's product started flying off the shelf. Audiences became obsessed with the charming trucker with a warm heart. Surprisingly, it was Chip's first time composing country music. But that never frightened the young composer. He knew that, like most songs, you needed a chorus, a verse, and a way to get in between the two. While Bill covered the vocals, Chip called in a rhythm section from Nashville to give the C. W. McCall ads an authentic sound. C. W. McCall's Old Home ads were becoming Chip's bread and butter. The next year, Chip was named the Country Music Writer of the Year.

Before long, C. W. had his own record deal. Chip and Bill filled out an album with songs inspired by the commercials like "Wolf

Creek Pass" and "Old Home Fill-'er-Up an' Keep on a-Trucking Café." After they pressed the record, they needed to get it out in the world to find its audience. The record company, however, only gave them a measly five dollar marketing budget. Thankfully, Chip knew how to make a lot out of a little. He changed that five dollars into quarters and marched into bars and cafés all over Omaha. There, he'd drop a quarter into the jukebox, play five of C. W.'s tracks for the entire restaurant, and watch as people sang along to the trucker's tunes.

These commercials became so successful that audiences were buying out the C. W. McCall albums as quickly as they had gobbled up Old Home Bread. C. W. McCall was something uniquely American, hitting a chord in both cities and the countryside. Perhaps C. W.'s most popular song, "Convoy" was a number one hit in 1976. Like most of C. W.'s other songs, "Convoy" was narrative. It told the story of an alliance of truckers and the friendships and hardships they encountered on the wide highways. It was later turned into a film directed by Sam Peckinpah. Chip composed the soundtrack.

Chip's music for C. W. McCall evoked a new wild west, one interweaved with highways and byways to be explored. Chip had tapped into a part of America that yearned for adventure and excitement. In C. W. McCall, Chip created a new piece of Americana culture—the glorification of the eighteen-wheel trucker. These men were fearless and warm, much like Chip. They never backed down from a challenge, and most of all, they were loyal to their friends and convoy-mates.

As Chip was writing music for C. W., he found himself surrounded by young musicians from across the country with different passions and interests. While Chip enjoyed writing C. W.'s music, he still had an impulse to create music at a larger scale. He wanted to explore the classical side of his training and elevate the works of great masters for a twentieth-century audience. Most importantly, however, he wanted to give his new colleagues a chance

to exercise their own musical talent. With these musicians, Chip founded the Mannheim Steamroller, a brand new orchestra for the twentieth century.

During the day, Chip would write jingles. At night, he'd trade in those jingles for studio time with his musicians. Chip wanted to pay homage to one of his favorite composers in history: Johannes Sebastian Bach. He and his musicians began by playing Bach's "Air on the G String." With his group, they'd fidget and fuss with these old melodies on their new instruments. The melody stuck but the sound was new and exciting. They started working on an album together and called it *Fresh Aire*.

Unfortunately, however, the Mannheim Steamroller couldn't find a label to sponsor them. Their music was fantastic, but MGM Records—the label who covered C. W. McCall—didn't feel they had as wide of a reach as Chip's trucker counterpart. Undeterred, Chip decided he'd create his own solution to this problem. He founded his own label, American Gramaphone, to handle the release and distribution of the record. Chip didn't have a manual to tell him how to make a record label, but he knew he could build something worthwhile. Over the next couple of years, he would have a lot of on-the-job training.

Chip and his Steamroller began booking gigs wherever they could get them. Since a large majority of the orchestra also played for C. W. McCall's concerts, their rehearsals often overlapped. On one booking, the opening act for C. W. McCall canceled last minute. The booker came to Chip with the bad news, explaining that they couldn't find a new band to perform on such short notice. Chip, however, offered a solution. Let the Mannheim Steamroller open for C. W. McCall. The orchestra members—who performed McCall's concert in blue jeans and T-shirts—put on tails and waistcoats over their casual clothes to perform their Mannheim act. And the audience was none the wiser.

As Chip was performing for these new audiences, he gained invaluable insights that allowed him to tweak and fidget with

Mannheim's performance night to night. He realized that his audiences were really hungry for holiday music. They wanted a new way to ring in the holiday. So he and his musicians delved into holiday classics. Quickly, they added their spin on yuletide tunes such as "O Holy Night," "We Three Kings," and "Deck the Halls."

In the 1980s, their interpretation of these holiday classics became incredibly popular. Before long, they were pressing albums entirely dedicated to holiday music. While ticket sales to their concerts were doing great, the albums were not moving as quickly as they would have liked.

Chip made the executive decision to decrease the price of their first Christmas album during the holiday season. This cut drove up record sales immensely. After that, Mannheim Steamroller was almost synonymous with the holidays for many families that loved and cherished Chip's compositions. Today, the Mannheim Steamroller has sold more than forty million records and has achieved multiplatinum status.

To this day, Chip is still composing, but, just like his high school days, he's still curious about all the world has to offer. On his ranch, he raises several kinds of animals including horses and wolves. He's currently cowriting a trilogy of novels on two of his animals entitled *The Wolf and the Warlander*. He is also studying astronomy with the help of his fourteen-inch telescope in his formal observatory.

Chip never let fear get in the way of something he wanted to get done. He was relentless in the pursuit of his dream. And he always knew the right tweak or twist he needed to give to make his career work. He's still tinkering with the Steamroller today. There are two separate orchestras that he switches between for performances. But as they roll into their most popular season, December, he often has members switch between the two so that they stay on their toes. After all, for Chip, staying alert means you're always ready to take on whatever the world has to throw at you.

## ARTIST-ENTREPRENEUR TAKEAWAYS

Making a big decision is hard. Often, we toil over which choice will result in which outcome or we get stuck in a constant loop of fretting so that we lose sight of our true goal. Chip, however, flipped the script on his decision making. Instead of tackling large issues, he'd make small incremental steps to make his goal a reality. These everyday tweaks, which look small in the moment, led to monumental changes for Chip and his career. However, it was his goal-oriented perspective, his entrepreneurial spirit, and his diverse knowledge that allowed him to make the small choices that paid off big in the end.

As a child, Chip was musically gifted, but he knew that he didn't want to just be a musician. He had the goal to make music his career, no matter what it took. His goal-oriented determination was what drove him to make the incremental changes he'd need to survive in the music business. To pay the bills, he found a job writing jingles. It might not have been the most glamorous position, but it led to momentous change for Chip. But that was Chip's nature: he'd jump at any chance to work in music. What are small goals you can set in your own career? What are some other options you can explore within your field that might result in fruitful connections?

When it came to Chip's career, he wouldn't let a "no" get in the way. He blazed his own way forward much like the trucker he wrote music for, C. W. McCall. Chip had an entrepreneurial spirit that led him to create his own opportunities. It started in high school, when he went to each music store selling his own customizable reeds. It led him to take out a roll of quarters to advertise his C. W. McCall record. And it was with him when he started his own record label: American Gramaphone. Chip didn't have experience in any of these things before he did them; he was just a musician. But his sense of entrepreneurialism led him to take risks that paid off big in his career. How do you define your own

entrepreneurialism? How do you make opportunities for yourself when none seem to appear?

Chip's determination and entrepreneurialism, however, would have been nothing if he didn't have the skills to back it up. Chip had a vast and diverse knowledge set when it came to music. When it came to composing country music, he was no pro when he started. His knowledge of classical composition, however, helped him compose some of the most recognizable country music ever. And he never would have had this knowledge if he hadn't secretly taken classes in other areas during high school and college. What are some tangential areas to your own skill set? How can you familiarize yourself with those things that will be beneficial to your career?

It's not easy to turn a steamroller. The machine rolls over almost anything that's in its way. Through small adjustments, however, an expert driver can steer it wherever they want to go. It can press a new road unlike any other that's been traveled before. Chip has piloted his music career as a steamroller—turning it inch by inch toward his goal. Through these minute changes, Chip created a career unlike any other, a career unique to the wild America that he embodied in his music.

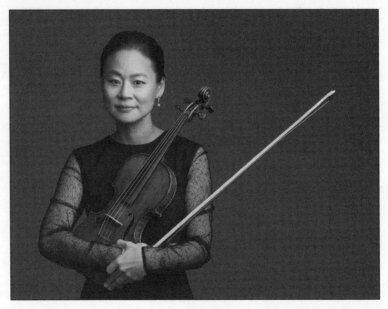

Midori

# Midori

## *Three Dauntless Violins*

It was humid when the Boston Symphony played Leonard Bernstein's *Serenade* at the Tanglewood Music Festival. Despite the heavy night air, it was a perfect setting in which to hear the master's work—and to see him conduct his own composition no less. Because of the muggy heat, the orchestra members had decided to perform without their jackets.

For this performance, a fourteen-year-old Japanese virtuoso named Midori had been invited to be the soloist. It was hard not to notice her young face, which stood out from those of the veteran instrumentalists in the orchestra. As she marched to take her place, she held her violin at her side. She was performing on what is referred to as a "del Gesu" made in the 1700s by Bartolomeo Giuseppe Guarneri, considered by many to be one of the greatest violin makers of all time. Since many of the instruments of that time were slightly different in size, her del Gesu was smaller in contrast to that of the concertmaster of the orchestra, Malcolm Lowe. His was one of the famed Stradivarius violins that are more renowned among the general public. While an otherwise insignificant distinction between instruments, this size differential was to provide young Midori with one of the earliest demonstrations of a key entrepreneurship skill set: creativity needed to ultimately accomplish a dream.

Bernstein tapped his baton and the concert began. When it came time for Midori's piece, the Maestro flared his arms as he conducted Midori and the orchestra through a perfect version of *Serenade*. The work is in five movements, combining various

forms, jazzy rhythms, dance-like elements, and varied harmonic structures. Both from the standpoint of stylistic and technical requirements, this piece demands incredible mastery and maturity. The melodic sections of the work poured out of Midori's violin in endless lines, and her passagework was impeccable. The audience soaked up every note.

Suddenly, with a sharp twang, Midori's perfect performance was interrupted, leaving the grim potential for disaster in its wake. Already an experienced young performer, she quickly realized what had occurred. The E string of her violin had broken. The thinnest and most delicate string had burst asunder—leaving the instrument virtually unplayable. With the professionalism of a much older musical star, she glanced at the conductor and then looked back at the concertmaster, Mr. Lowe, who was already offering his own violin for her to continue her solo, fulfilling a customary gesture when this rare circumstance occurs on stage. Midori took the instrument and resumed the piece.

But his violin was a long-pattern Stradivarius, which meant that it was quite different, a bit larger than her own del Gesu. Midori made do and played on as though nothing had happened, trying to incorporate the incalculable nuanced changes that now needed to take place in her hand position, slides, and other details that are the necessary component of her extraordinary artistic delivery.

Then it happened again: the same twang disrupted the otherwise resonant setting and threatened this unique moment she was experiencing with the conductor, orchestra, and, most importantly, audience. Midori looked at Mr. Lowe's violin in her hands and saw that—again—a broken E string disappeared from where it was supposed to be strung tight. The orchestra continued while Midori looked back at Mr. Lowe, who handed her a third violin— the second chair's violin, now an extremely rare occurrence but still in accordance with the expected sacrifice on the part of the highest-ranking violinists in the orchestra. The show must always go on. The classical music business is, after all, still show business.

Midori finished the movement. Before she could put the borrowed third violin down, the audience exploded in applause and adoration. Her tiny feet left the floor as Leonard Bernstein, the master himself, wrapped her in his arms and showered her forehead with kisses.

The concert was an unqualified success, thanks to Midori's character and persistence. The next day the *New York Times* ran a front-page story under the headline, "Girl, 14, Conquers Tanglewood with 3 Violins."[1]

Midori Goto—who simply goes by her first name—was born in Osaka, Japan. Her mother was a professional violinist. As a toddler, Midori would hear her mother play at home. As soon as she learned to crawl, Midori would reach for her mother's violin. By the time she could speak, she could hum Bach concertos from memory. On her fourth birthday, Midori's grandmother bought her a one-sixteenth-size violin and her mother began to instruct her in the instrument.

Although Midori considers her mother her greatest teacher to this day, at the time, it soon became clear that identifying an accomplished renowned pedagogue would be ideal if they were to develop Midori's potential to its fullest. She possessed a rare talent and immense determination, and she would practice for hours on end. Her sense of pitch and memory were impeccable. She could listen to a piece and then play it almost flawlessly after only limited focused practice. Her mother knew that Midori needed an accomplished teacher who could help shape her talents. She also wanted to explore what opportunities could present themselves to Midori beyond the immediacy of Osaka.

One day, Midori's mother was giving a performance and, as she was oft to do, Midori found herself practicing in her mom's dressing room. One of her mother's colleagues heard her and

requested a tape be made so as to bring evidence of Midori's talent to the States. Her mother obliged and made the tape, which ultimately found its way into the hands of acclaimed violin teacher Dorothy DeLay. Midori's tape intrigued DeLay, who invited the nine-year-old girl to attend the 1981 Aspen Summer Music Festival. So Midori's mother packed a pair of suitcases and her violin, and the two of them left Japan for Colorado. Midori's journey had begun.

At the festival, Midori played a variety of compositions that frustrate even expert violinists. But Midori was unafraid of complexity, and her performances overall along with her developing relationship with DeLay landed her an audition for the pre-college program at the Juilliard School in New York, to become a part of DeLay's violin class at the same institution.

The young soloist was drawn to difficult pieces. At an age when other girls would play make-believe or dress-up, Midori would commit hours of practice at home to perfect notoriously challenging compositions by the great masters. For her Juilliard audition, she performed the incredibly difficult Paganini Concerto and, during the same period, played Bach's thirteen-minute baroque masterpiece, *Chaconne*—considered by many to be the greatest solo piece for violin.

*Chaconne* demands focus and proficiency from those who attempt to take it on. DeLay would sit and listen to Midori play every note, marveling at her talent and precision, and provided leadership guidance through her studies in New York at the Juilliard Pre-College School.

When we think of great teachers, some often have the image of the stern instructor: the ballet teacher with a stick in hand to swat at errant limbs, the acting instructor shouting from the back of the studio, the piano tutor who places pennies on the fingers of her pupils as they play. But DeLay's teaching style was the complete antithesis of this. DeLay didn't just want her students to play well; she wanted to impart to them a greater understanding of

music. Her method was strictly Socratic—she encouraged students to think by asking them questions. When she started on a new piece with a student, she would ask the student what the music meant to them. After a pupil played a piece in practice, she would ask them how they thought they'd performed. By forcing her students to explain themselves, she fostered curiosity in them. And that curiosity drove Midori's growth as a performer. She also sought out and learned from the greatest teachers and performers she could gain access to including the famed Isaac Stern, who challenged her thoughts about music and encouraged her to bring a stark honesty to her performing and understand her role as an interpreter on stage.

During her time with DeLay, Stern, and others, Midori realized that every performance is a set of exchanges between composition, performer, and audience. When she read a piece of music, she would interpret it through her own perspective, choosing to perform it in a way she felt was true to the composer. When she performed the piece, however, each listener would take in the performance in his or her own individual way. Midori came to understand that each performance was a gift that she had to give willingly, and each audience member would receive that gift however he or she wanted.

At fifteen, after her performance at Tanglewood, Midori's name was no longer merely being whispered in select circles; she was a household name and an international sensation. The *New York Times*, the *Washington Post*, and other papers of note were scrambling for interviews with the wunderkind. Each day, a new orchestra was asking her to solo with them. This wave of interest and the understanding that her professional career was already upon her prompted Midori to leave the Juilliard Pre-College to become a full-time concert violinist.

She'd prepare for these concerts in relatively simple surroundings, practicing for hours uninterrupted. Her room was a minimalist space with little more than a music stand, bookshelves of

sheet music, a boom box, and some curtains to help minimize the sound carryover to her neighbors. While it seemed rather spartan, it also helped Midori to focus on her work. Practice was no chore for Midori but a pleasure that was deeply desired.

At eighteen, Midori made her debut concert at Carnegie Hall. The audience was an experienced one—filled with fellow violinists and seasoned classical music fans. The program for the evening featured works that had previously made for some of Midori's greatest performances. Her rendition of Bartok's *Violin Concerto 2* wrapped the audience in a warm embrace, and she evoked an emotional experience that was truly unique, even among the greatest musicians of our time. By the end of the night, Midori was enveloped by applause.

Her outsized reputation was belied by her petite stature. The *New York Times* reported that "she radiated a fragile vulnerability . . . but the moment her bow touched the strings . . . a transformation occurred."[2] An article in the *Los Angeles Times* called her "a slip of a girl" whose career "never so much as paused between lollipops and limousines."[3] More articles poured out noting her size, her age, and the seeming impossibility of her talent. Every journalist had an opinion on Midori, and she heard many of them.

Unlike other young performers, Midori was a free agent—her family had nothing to do with her career. With this freedom, however, came an added pressure she placed upon herself to succeed. With the unexpected outpouring of opinions from newspapers and media outlets, she felt unbalanced by the spotlight. The press loved to adjudicate child prodigies and would often boast dire predictions that they would never last past age twenty. This created an antagonistic environment in which Midori found herself fighting against an artificial expectation to fail. Through the combination of these circumstances along with aspects of her personal background, the teenager spiraled into a depression that completely changed her life. At nineteen, she canceled a portion of her season to take needed time for herself.

Midori's break was only about three months, though this didn't stop the press from implying an intermission of far greater length. While her career as a violinist had flourished, her emotional life had become rife with depression and pain. In order to take care of herself, she sought help from family, therapists, and psychologists. Midori loved to perform but knew that her drive for perfection came with a cost. She couldn't control everything; at the same time, she had others trying to tell her how to design or architect her own life. She was curious to learn what else she could do. At twenty-five, Midori fulfilled her earlier desire and went to college—and not for music or violin.

In 2000, Midori graduated from the Gallatin School at New York University with a double concentration in psychology and gender studies. While at NYU, Midori became fascinated with the inner workings of the human mind. Her curiosity was limitless, and as she consumed articles and reports, she began to fall in love with the learning process itself. She continued her education, eventually earning a master's degree in psychology.

Adding education to the repertoire of her life during this period rejuvenated Midori. The process sparked a desire to teach others the skills she had become so renowned for: music and performance. This was easier said than done, however. From her time in orchestras and concert halls, she was keenly aware that her talent and position had been a privilege. Many who aspired to be musicians were denied the kind of training she'd had access to. Barriers like class, race, and location kept many aspiring musicians out of institutions that could benefit them. Access to classical music was not equal, and Midori wanted to see that change.

Before Midori took her brief break, she had founded Midori & Friends, an educational organization with a mission to bring music education to schoolchildren in New York City's public schools. Midori & Friends was created as a reaction to cuts in arts

funding by a variety of governmental entities, in order to bring music back into the public-school system. Through music classes, lessons, and group instruction, Midori & Friends encouraged kids who had never had a course of musical study and provided access across a broad range of music including classical, jazz, folk, and other genres.

After Midori graduated from NYU, she continued to invest a significant amount of her time in Midori & Friends. She regularly performed in schools around the five boroughs. She was involved in the development of new curricula to include jazz, folk, and other styles of music. This was a way she could give back without becoming mired in the old world of music stardom, which was stultifying. During this time, she had also founded an equivalent program in Japan. As she delved into the administrative realities of this social entrepreneurship, Midori brought the same focus and attention to detail that epitomized her practice sessions for performing. As a result, she adapted the program in Japan to accommodate the regulatory and governmental realities of the region and separated her U.S. work, which had the formal nonprofit designation of Midori & Friends, from her work overseas.

This led to the new designation and evolution of Music Sharing, the nonprofit headquartered in Midori's native Japan. Music Sharing brought Western classical and traditional Japanese music to underserved populations throughout Japan and various developing areas in the region, though the focus was and remains Japan. The organization is still operating today and has expanded to providing musical instruments and lessons for children with disabilities as well as programs bringing not only Western classical music but also traditional Japanese music to schools, hospitals, shelters, and child-care facilities across Japan. Since its founding, the organization has reached more than 250,000 persons in institutions all over Asia.

In 2001 Midori won the Avery Fisher Prize,[4] and she used the money to start a new nonprofit venture—the Partners in

Performance organization. Midori had noticed that small-town music presenters were disappearing in rural areas across America. These communities had no operas and no orchestras—they were suffering in their ability to bring quality art to their residents. Aimed at bringing excellent music to rural communities in America, "PiP" partnered with and empowered rural presenters producing concerts and providing chamber music and classical music experiences for small towns across the United States.

Midori's many educational initiatives have all been focused on bringing people together through music. Her passion for access has enabled thousands to appreciate the music she loves. In no small way, her influence has changed the course of countless lives around the world, and her compassion has allowed many young people without access to develop and many communities without means to flourish despite their circumstances.

Today, Midori continues her career as a soloist and educator. While it is true that Midori showed natural talent at a young age—taking up the violin as another child might take up a toy—it is Midori's life journey that has made her who she is now. The persistence she developed in the face of adversity has enabled her to give countless dazzling performances and change the lives of the people she touches.

While the trope of the "young genius musician" stretches back to Mozart, Midori's story is fundamentally different from Mozart's in one way: her career was always her own. Whereas Mozart's father took commission for his son's appearances, Midori has made every career decision for herself. She chose compositions to perform that many would consider beyond her—and nailed them. She founded Midori & Friends mostly on her own before she turned twenty—a feat many teenagers couldn't even begin to contemplate. Her entrepreneurship has been inextricably linked to her

strong personality, and art entrepreneurs would benefit by taking note of three aspects of that personality: her persistence, her adaptability, and her ability to assess her limitations.

## ARTIST-ENTREPRENEUR TAKEAWAYS

Be relentless in your passion. As a teenager, the hours Midori spent practicing turned into afternoons, and afternoons became evenings. She would not and could not leave her practice space until she performed a composition flawlessly. This persistence made her practices productive. And the same ambition that kept her in the studio inspired her to build myriad educational organizations. Have you found that which truly keeps *you* going every day? If not, are you allowing yourself to search for it? If so, are you creating the time and place in your life for this whole-hearted pursuit?

Be adaptable. Persistence is important, but it can be pointless without flexibility. Throwing yourself against a problem repeatedly without trying a new tactic rarely solves the problem. Midori demonstrated great adaptability in these situations; look to her performance at Tanglewood to see how she could adjust to an unforeseen circumstance. While Bill T. Jones had a variety of factors including a tremendous loss that served as a catalyst for adaptability, Midori was facing the constant need to evolve artistically and professionally. As a soloist and as an educator, she was able to take in her surroundings and adapt herself to fit the needs of the moment. What are the problems that continue to arise in *your* work? Have you tried taking a step back and reassessing the situation? How can you cancel out the noise and hone in on what is important?

Remember the balance. Midori was so busy hustling to build the career she desired, she didn't realize how important it was to focus on and take care of herself if she was to have the impact in

the field that she wanted to fully realize. Midori learned the limits of her capacity the hard way when she took a brief break from performing at nineteen. She needed that break, however: Midori realized she couldn't continue to function as an artist if she didn't take care of herself. And happily, the time away brought new areas of interest into focus for her. Do you know your own capacity, and do you know when it is at its limits? How can you take time away to clear your head? In what ways can you build your stamina?

Expand your horizons for a full reward. Midori's journey has given her the opportunity to work both as a performer and as a teacher. This breadth of experience has elevated her style of teaching, expanded her awareness, and heightened her performances. While she continues to perform, she now finds that her primary stage from which she impacts individuals and communities is far more broad and is comprised of the intricate mosaic that is the portfolio life she has built over time. To Midori, this is the ultimate reward.

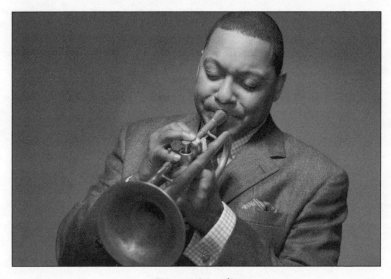

Wynton Marsalis

# Wynton Marsalis

## *The Box and the Horn*

It was just a box, bulging at the edges under the weight of its contents. Some secondhand clothes, a boom box, and as many cassette tapes as could fit pushed against the walls of their new cardboard mobile home, carefully taken from their places in the teenager's room. The seventeen-year-old boy was leaving home to go seek his fortune as a musician. His beloved instrument was neatly tucked inside its case, waiting for him to breathe life into its brass valves. As he lifted the box, he turned around to look at his room one last time. His father stood in the doorway, looking melancholy.

"What's in the box?" the father asked.

"Nothing," the boy replied.

The father cocked his eyebrow. "Nothing?"

"Not much," the boy corrected himself. "Some tapes, some clothes, enough for me to get by."

"It's enough?" the father asked again. Would his boy want for anything?

"It's enough."

"Well, then." The father was satisfied. "Just remember, if you ever get into trouble, all you need is in that box there."

That's when Wynton Marsalis marched out of his father's house and began his own journey.

As a young boy growing up in the South, Wynton saw his father struggle as a jazz musician. Ellis Marsalis Jr. worked tirelessly to land gigs to provide for his family and do the art that he loved. And Ellis wasn't exactly an unknown musician. In fact, he was known throughout New Orleans as one of the best jazz pianists around.

The jazz clubs and concert venues weren't always the best place to take a kid, but for the Marsalis family, it was almost like baby-sitting. The kids would sit and watch their dad as his hands blurred over the piano keys, their mother eagerly waiting for the gig to be over so she could put them to bed. But encore after encore only riled them up. Despite Ellis's many successful gigs, Wynton needed to mow lawns to help the family make ends meet.

It's hard to imagine Wynton Marsalis, the famed musician who started a jazz renaissance, mowing a lawn for six or seven dollars. For Wynton, however, this manual labor was just a means to an end. Money was never the object but rather a product that would give him the opportunity to perform. And in a family full of performers—his five other brothers were also musicians—Wynton had a built-in community and learned jazz by trying to outplay his siblings in their friendly rivalry. His brother Branford played the saxophone, Delfeayo played the trombone, and Jason was a drummer.

When Wynton wasn't playing with his family, he was blowing his trumpet on the streets of New Orleans. Influenced by the spirit of the bayou, Wynton tried to capture the sound of New Orleans and the people who called that city home. Jazz and swing were everywhere, and Wynton got caught up in it. At eight, he played with legendary banjoist Danny Barker—a mainstay of the New Orleans jazz scene. Blaring on his horn in the Fairview Baptist Church, Wynton realized he couldn't imagine doing anything else with his life. From that moment on, he pledged to himself that music would be his life.

Wynton attended the New Orleans Center for Creative Arts, where he practiced diligently to learn everything about the

trumpet. As a seventeen-year-old, he was the youngest musician to be admitted to the prestigious Tanglewood Music Center. A year later, he found himself at Juilliard, where his faithful box was unpacked in his dorm room.

Throughout this journey, Wynton got used to being the young man in a room full of older people; most of his colleagues were ten or twenty years his senior. But this didn't scare Wynton. It humbled and enlightened him. It was an opportunity for him to draw on their countless years of experience. Then, at Juilliard, he found peers his own age with whom to collaborate and communicate. This variety of experiences molded Wynton into a performer who was open and available—no matter what was going on in his head. He began to treat his life like jazz music.

During his sophomore year at Juilliard, Wynton earned a grant from the National Endowment of the Arts. With the grant money, he was given the opportunity to study under a master—the great Woody Shaw, a jazz trumpeter with perfect pitch. For Wynton, Shaw was a revelation, both as a musician and as a human being.

While studying at Juilliard, Wynton booked several gigs around New York City. Through the early 1980s, there wasn't a weekend when Wynton's trumpet wasn't blowing somewhere on the island of Manhattan. And it wasn't long before people heard him. Audiences were captivated by his sweet, soft demeanor, which belied the power of his instrument.

Wynton's virtuosity drew like-minded musicians to his shows, which gave him the opportunity to network. In 1980, he began playing with the Jazz Messengers, a legendary New York City jazz swing band led by the iconic drummer Art Blakey. In this group, Wynton found his family—literally; his brother Branford was on sax. At around this time, his growing reputation earned him the opportunity to play with such jazz legends as Dizzy Gillespie, Sweets Edison, Sarah Vaughn, Sonny Rollins, and Herbie Hancock—who had by then become one of his mentors.

Playing with these legends soon brought Wynton to the attention of the music industry at large. At one of his performances, a representative from Columbia Records approached him with a record deal. Suddenly, the boy who had cut grass to help his family get by was being offered the proverbial golden ticket—a way to make his living playing music. He quickly assembled a band to record an album—a band that included friends and family like Branford as well as big names like bassist Ron Carter and of course his mentor Herbie Hancock, who also produced the album.

But for Wynton, the cliché record deal wasn't enough. Jazz wasn't meant only to be pressed and preserved in vinyl. It needed to breathe and to be played in front of audiences. So he packed up his horn and his box and took his band on the road. From small towns to big cities, Wynton and his band would play anywhere, and each composition changed nightly, depending on the band's mood. One night in Louisville, the next in New Orleans, and another in Galveston, Wynton was reintroducing America to the beauty and wonder of jazz. Shows everywhere were sold out. That year, Wynton played more than one hundred and twenty shows throughout the United States and Canada, and he'd maintain that pace for the next fifteen years.

Through playing his horn, Wynton realized that elements of his music could be applied to his life. He began to embody the spirit of the music he served. By playing the blues, he found that optimism is something to be earned. And in improvisation, he learned how to be flexible in negotiating with others. Little did he know how well these lessons would serve as he blew into the next phase of his life.

As Wynton matured as a bandleader and instrumentalist, he began to crave new challenges. He had already reignited the fire of jazz

and blues across the world, but he began to wonder what else he could do. He knew Bach and Beethoven as well as he knew Blakey and Basie. His jazz upbringing was infused with a deep knowledge of classical music that primed him to compose. But what would he compose?

Wynton realized he wanted to leave a legacy that could inspire new students of jazz, and this epiphany was the catalyst for Jazz at Lincoln Center. Cofounded by Wynton, the organization started as a summer concert series—a way for Lincoln Center to use its empty theaters during the summertime. Wynton gathered both students and professionals in the New York jazz scene to play, and audiences flocked to the performances.

As Jazz at Lincoln Center (JALC) became more popular, the organization grew and evolved. Today it is not only a center for performance of jazz and swing music but also a source for education about jazz.

Over the years that followed, it became clear to Lincoln Center that JALC was one of their most successful endeavors, and in 1997 they made it a full-fledged constituent of the Center, putting it on the same footing as the New York Philharmonic, the Metropolitan Opera, the New York City Ballet, and the rest of the programming at Lincoln. Since then, Wynton and his organization have continued to advance the JALC's mission to "entertain, enrich and expand a global community for jazz through performance, education and advocacy, and to bolster the cultural infrastructure for jazz globally."

One could argue that JALC was one of Wynton's greatest "compositions." He brought performers together to create music— one of the goals of a great composer.

When writing music, Wynton drew from all styles, from classical to New Orleans jazz to bebop and modern jazz. He was a

musician with broad interests, and he wanted to bring all of them to his work.

In the mid-nineties, he began to collaborate with the Lincoln Center Chamber Music Society to compose and create. This collaboration led to several pieces, including *At the Octoroon Balls* and *A Fiddler's Tale*—a piece inspired by Stravinsky's *A Soldier's Tale*. Wynton's compositions moved with speed, elegance, and imagination, so naturally this style enticed choreographers such as Twyla Tharp and the Alvin Ailey American Dance Company to commission pieces for dance performances.

As great as they were, all those compositions were just a prelude to Wynton's great work: *Blood on the Fields*, a jazz oratorio that told the story of an African American couple's journey from slavery to freedom. In *Blood on the Fields*, Wynton incorporates music from every generation of African American culture to weave a tale that expresses the full scope of his people's heritage. Utilizing work songs, chants, Afro-Caribbean rhythms, and Ellingtonesque orchestrations, Wynton paints a portrait of a traumatized and beaten people who are only able to uplift themselves through music. In 1997, *Blood on the Fields* was awarded the Pulitzer Prize for Music— the first jazz composition ever to be awarded that honor.

Wynton had become the master he'd always aspired to be. His name was now synonymous with jazz. In 1996, he premiered a PBS television show called *Marsalis on Music*, which educated children and adults alike on the basics of music theory: rhythm, melody, structure, and improvisation. Wynton worked with the acclaimed conductor Seiji Ozawa to illustrate his lessons. In this new medium, he furthered his personal mission: to educate and inspire people around the world.

Throughout his life, this mission has driven Wynton. He worked to be the best, and that's exactly what he became. His indefatigable sense of purpose has made him one of the best jazz performers of his generation.

Wynton's great success was due to his talent and hard work. That being said, he discovered early on that he needed to develop a system that would organize his process in a way that would allow him to create and perform. His "Twelve Principles of Jazz Business" was that system. In these twelve principles, a creative entrepreneur can discover their own path—one that will enrich their own business and artistry.

## WYNTON MARSALIS'S TWELVE PRINCIPLES OF JAZZ BUSINESS

### 1. Embody the Music You Serve (Soul)

Improvisation, blues, and swing are the essences that define jazz music. They are also fundamental to our political processes and our way of life. *Improvisation* is personal freedom. *The blues* is earned optimism. *Swing* and the *act of swinging* place a premium on negotiating skills.

I would argue that this is the most important of these principles that Wynton espouses. Essentially at its heart, this is you, your artistic persona. You should ask yourself, "Do you reflect your creativity?" Whatever it might be, there should be an alignment between who you are and the artistic expression you bring to bear. Wynton literally is his music. It defines who he is, and whether it was the Jazz Messengers, *At the Octoroon Balls*, or *Blood on the Fields*, his existence is defined by his musical persona. Wynton lives an improvisatory life. Every artist-entrepreneur should think about this relationship between themselves and their art and strive to fuel those connections.

## 2. Inspirit Your Surrounding Environment (Spirit of Place)

The irrepressible spirit that created our music inhabits it. We often begin with enthusiasm and a "conquer the world" attitude, only to stumble and fall back into an uninspired day-to-day grind. Now is always a good time to change your immediate environment by investing in yourself. Share your own spirit.

## 3. Seek to Expand Your Extended Family and Help Them Help You (Community)

Our music encourages virtuosity, flexibility, emotion, and good manners.

Virtuosity indicates that you are technically prepared to improvise with substance on something you may be encountering for the first time. *Flexibility* indicates that you are a patient listener who can understand and respond intelligently (even to ideas beyond your musical comfort zone). *Emotion* pressures you to address the human demands of playing with and for people. *Good bandstand* manners are evidenced when you seek parameters that include everyone.

## 4. Catalog and Make Easily Accessible All Content (Identity)

In music, documentation is the singular path to an immortal now-ness. Accessible and comprehensive archives testify to your existence and provide substantive material to support your future. Document yourself and make it easy for the world to find you.

## 5. Constantly Simplify and Refine Administrative Plans and Documents (Methodology)

In most administrative interactions, documents govern procedure. Just as a composer works and re-works a score, significant

administrative plans and procedures should be subject to constant evaluation, revision, and simplification.

## 6. Insist on Understanding Accurate and Transparent Institutional Metrics (Integrity)

Numbers are the most objective tools we have. In order to be successful, an institution must be results-driven, goal oriented, and metrics focused. When a musician is really familiar with a chord progression, he/she is free to invent endless melodies. A well-constructed framework encourages freedom; it doesn't constrain it.

## 7. Integrate Access to Information and All Aspects of Our Business (Communication)

Information and its communication are the lifeblood of any non-reflexive group activity. In an organization with specialized groups, everyone must have access to and understanding of the same pool of information if groups are to intelligently realize larger objectives. When there is a common understanding and language, even the most involved undertakings can be efficiently managed.

## 8. Embrace the Creativity of All Staff and Nurture Fresh Ideas (Wealth)

Improvisatory freedom is a byproduct of the time invested in learning the language and gaining the courage to use that language to tell an audience how you actually feel. No "system" should ever force us to abandon the freedom to embrace new ideas.

## 9. Provide a Point of Entry for All Possible Participants Regardless of Sophistication (Hospitality)

The arts are misperceived as elitist because they have been presented by an exploitative commercial market place, and because they are largely supported by people of means and people with the best education. Jazz is and has been populated by all kinds of folks from all over. No one has to be anything but themselves to belong. Everyone and anyone is welcome. Any successful arts organization should want to foster the highest possible quality of experience for the widest possible audience.

## 10. Offer Everything, All the Time, Everywhere, at Any Level of Participation (Health)

The flexibility and egalitarian spirit of the music makes it eternal. Jazz is at home everywhere in the world. Access helps sales. You don't have to charge everyone for everything all the time.

## 11. Value Metric Success but Not at the Expense of Mission (Purpose)

The power to evoke, inspire, and reorder human feeling and consciousness directly and immediately gives music a value greater than its sale or even its own underlying structure. Quality is more important than quantity.

## 12. Celebrate Our History and Traditions as We Create the Present Moments of the Future (Legacy)

To fulfill our purpose with passion, excellence, and integrity, it is crucial that we learn about ourselves [and] where we come from, and say outright where we want to go.

## ARTIST-ENTREPRENEUR TAKEAWAYS

Be original. Since Wynton so aptly shared these principles, I will let them stand as the takeaways for his chapter, only emphasizing the importance of originality. Wynton built a life for himself out of music. While he always had a firm hand on his trumpet, he also had his keen eye on his career and future. Thanks to his ingenuity, he was able to combine his entrepreneurial spirit with his musicality. He has embodied the freedom and flexibility of jazz throughout his life. As you begin your own artistic journey, consider how you can emulate the flexibility and adaptability of the great jazz masters.

# Conclusion

## *Da Capo Al Fine*

In music there is a term that is used to signify repetition: *Da Capo Al Fine*, from the head (beginning) to the end. D.C. al fine is an indication to repeat from the beginning of the music and continue until you reach the final barline or a double-barline marked with the word *fine*.

I've chosen to conclude my book with this instruction. Being an artist-entrepreneur is tough. Just as you hone your craft with a weekly rehearsal schedule, you must bring that same iterative practice to your career. The lessons you may have learned from your first reading of stories enclosed here are invaluable, but I assure you that if you pick it up again in the future, you'll uncover new ideas that will guide you further along.

The lessons from these giants aren't only for artists, however. Any entrepreneur at any stage in his or her career can learn from these masters. Starting with anyone in this book and incorporating his or her strategies into your daily practice, your only limits are those you set yourself. Even if you're the CEO of a Fortune 500 company, the lessons to be gleaned from the lives of these art entrepreneurs can help you grow your business with passion and ingenuity.

With the obvious exceptions of Shakespeare and Mozart, I had the honor of interviewing all of the figures profiled in this book. As I spoke to these artist-entrepreneurs, their grit, commitment, and genius inspired me. I see my own journey reflected in each

of their paths, and it compels me to recommit to my own artistic endeavors, while always keeping an open mind on new ventures and possibilities. These people embody qualities that unite creatives from all disciplines; we all share traits that compel us to create. From Shakespeare's time to the present day, the mission of artist-entrepreneurs hasn't changed: to evolve our world through creative practice.

While each subject of this book is an individual, each of them created a structured process for inspiration, which encouraged them to create. They showed grit and confidence in the face of failure. They had unique perspectives that allowed them to learn from their missteps. They learned how to communicate their ideas in a way that excited like-minded individuals. Together with their collaborators, they grew communities that sparked new movements.

Inspiration is often described as a lightbulb moment that compels an artist to create. The truth, however, is that inspiration can come in all forms, uncertain, untimely, and it might not come for months at a time. These artist-entrepreneurs didn't have time to sit around and wait for ideas; they went out and got them, working from what they had, starting from what they knew. Lin-Manuel Miranda saw a need to tell the authentic story of his community on Broadway, so he wrote *In the Heights*. Jeff Daniels had a passion to cultivate new plays, so he built his own theater as a laboratory for him to experiment, and now the Purple Rose has reinvigorated the cultural scene in Chelsea, Michigan. By creating spaces for themselves to do their work, these artist-entrepreneurs rarely lacked ideas for new projects.

Another way that these geniuses kept their inspiration flowing was by guiding others. By sharing their inspiration, many of these artists were able to challenge their own perspectives. Midori and Rachel Barton Pine created educational initiatives to inspire and uplift new musicians. Even Mozart took students, albeit mostly for financial reasons. These artists created legacies by fostering the careers of others.

Determination was another factor in the success of these nine great masters. Shakespeare and Mozart broke from their systems of sponsorship to become artist-entrepreneurs, and their new status as free agents forced them to continually create new works: hunger drove them to keep going. Bill T. Jones exhibited this same tenacity when dancing through his own adversities—oppression, inequality, and the HIV epidemic. And Marin Alsop fought to become the first woman to lead a major symphony in spite of all the resistance she encountered from a male-dominated profession. Persistence in the face of hardship is essential to an artist's career.

To endure these trials, however, requires stamina. Even though they had immense talent, these artists were still human and still susceptible to exhaustion. They had to know when they needed a recharge, and mindful rest was key to keeping them on their hustle. Lin-Manuel took a long vacation after writing *In the Heights*—and it was on that vacation that he was inspired to write *Hamilton*, the musical that would transform his career and the field. When Midori took her own break, it evolved her life's trajectory. She went from full-time concert performance to a career path with far more breadth that incorporated impacting the underprivileged while enriching her own performing with a far deeper life experience informing her artistic interpretations. The hustle is hard work, and taking personal time away from your career can be a powerful way to gain inspiration and new insights.

The artist-entrepreneurs in this book were surrounded by supporters and collaborators who helped them to create their art. For Shakespeare, the King's Men weren't only actors that performed his work but talented improvisers who left their mark on his folio. Without this merry band, Shakespeare and his plays might have been lost to history. Wynton Marsalis had his own cadre of musicians in the Jazz Messengers—many of whom followed him on his prolific tours of the 1980s. In Arnie Zane, Bill T. Jones found a partner—in art and in life—and their relationship gave birth to

new forms of movement and performance that are utilized today. The subjects of this book leaned on their colleagues throughout their careers—through the good times and the bad.

Most of these art entrepreneurs had mentors to advise and encourage them when it was hard to see a way forward. Perhaps the clearest example of this is Marin Alsop's relationship with Leonard Bernstein, who took her with him when he toured the world. Wynton Marsalis also had many mentors, including Art Blakey and Woody Shaw. These former protégés of masters are now mentors themselves, passing their knowledge on to fresh new artists in their fields.

And now they have passed their knowledge on to you. You've read their stories and learned their methods. The next thing to do is the hardest—getting started. Take stock of your skills, your network, and your ambition in order to create a plan. What are the goals you want to achieve, and how will you achieve them? Whether you're a student, a recent graduate, or a working professional, planning and organizing will make you more productive and more receptive to creative inspiration.

The key is returning to your plan frequently. The goals you have created and the tasks you need to check off are your stepping-stones to success. Being an entrepreneur is an ever-evolving iterative process. Every day should bring you closer to your goals, but you have to *take* it—it doesn't just happen naturally. You get to Carnegie Hall through practice, practice, and more practice. Your career is your art. Bring to it the same passion and determination that you bring to your practice.

Our work is never truly done. As artists, we are always looking for opportunities—the next gig, another gallery opening, or an upcoming audition. Being an entrepreneur is not dissimilar. If you feel stuck, come back to the lessons in this book and use them to revive your thinking and unburden yourself from your own self-imposed limitations. When you feel tired, remember the feeling of accomplishment that rewards the act of creation. I hope that

this book has served you in your journey and that it becomes an essential part of your toolkit as you build your career. I return to so many of these processes and methods on a regular basis, to find inspiration, to uncover new moments of discovery, and to listen for something I missed, as I continually strive to intentionally architect a creative and fulfilling life.

# Notes

## WOLFGANG AMADEUS MOZART

1. David Corbett, *Portfolio Life* (New York: John Wiley & Sons, 2007).

## JEFF DANIELS

1. John Monaghan, "A Story about Flint and Its Troubles Takes the Stage," *Detroit Free Press*, January 24, 2018, www.freep.com/story/enter tainment/arts/2018/01/24/flint-play-purple-rose-theater-jeff-daniels/1056330001/.

## BILL T. JONES

1. Anna Kisselgoff, "Dance: Jones and Zane" *New York Times*, December 13, 1985, www.nytimes.com/1985/12/13/arts/dance-jones-and-zane.html.

2. John O'Mahony, "Body Artist," *Guardian*, June 11, 2004, web.archive.org/web/20170718214229/https://www.theguardian.com/stage/2004/jun/12/dance.

3. Anna Kisselgoff, "Review/Dance; Jones/Zane Company and Loss," *New York Times*, March 20, 1989, www.nytimes.com/1989/03/20/arts/review-dance-jones-zane-company-and-loss.html.

4. Arlene Croce, "Discussing the Undiscussable," *New Yorker*, December 26, 1994, www.newyorker.com/magazine/1994/12/26/discussing-the-undiscussable.

# LIN-MANUEL MIRANDA

1. Andrea Romano, "Odds of Winning the Hamilton Lottery Are Bleak, but Not as Bad as You Think," Mashable.com, May 26, 2016, mashable.com/2016/05/26/odds-of-winning-a-hamilton-ticket/#7Xw MxGHnCgq1.

# MARIN ALSOP

1. "Marin Q&A," marinalsop.com, accessed April 30, 2018, www .marinalsop.com/about/marin-qa/.
2. Barbara Kantrowitz, "When Women Lead," *Newsweek*, October 24, 2005.
3. Lev Grossman, "A Symphony of Her Own," *Time*, July 25, 2005, content.time.com/time/magazine/article/0,9171,1086150-2,00.html.

# MIDORI

1. John Rockwell, "Girl, 14, Conquers Tanglewood with 3 Violins," *New York Times*, July 28, 1986.
2. K. Robert Schwarz, "Glissando," *New York Times Magazine*, March 24, 1991, www.nytimes.com/1991/03/24/magazine/glissando .html.
3. Donna Perlmutter, "Midori: From Prodigy to Artist," *Los Angeles Times*, April 8, 1990, articles.latimes.com/print/1990-04-08/ entertainment/ca-1631_1_japanese-violinist.
4. The Avery Fisher Prize is an award given by the Lincoln Center to American musicians who show outstanding talent in classical music. It is considered one of the highest honors for a solo instrumentalist.

# Index

# INDEX

INDEX

self-expression, Daniels and, 25
Seller, Jeffrey, 47
*Serenade* (Berstein), 121–22
sexuality, Jones and, 33–35
Shakespeare, William, xxii*f,* 1–9
Shaw, Woody, 135
Shoreditch Theatre, 2–3
Simon, Paul, 45
skills, for entrepreneurship, xvii–xxi
Sneed, Damien, 66*f,* 67–75
social entrepreneurship: Dworkin and,
    xi–xiii; Midori and, 127–29; Pine
    and, 61–62
Sorkin, Aaron, 21, 26–28
Sotheby's, 62
soul, Marsalis and, 139
soundtracks, Gupton and, 99–100
Sphinx Organization, xi–xvii; Sneed
    and, 72–73
Sphinx Virtuosi, xv–xvi; Gupton and,
    104
*The Squid and the Whale* (film), 25
Stern, Isaac, 125
Still, William Grant, xi
*Still/Here* (dance), 39
Stradivarius, 121–22
*Stringendo: Storming the Citadel* (Pine),
    59
String Fever, 92

Tanglewood Music Festival, 94,
    121–23, 135
teaching, 146; Marsalis and, 138;
    Midori and, 127–28; Mozart and,
    15; Sneed and, 72
technology successes, versus artistic
    approach, xviii–xix
television, Gupton and, 106

*Terms of Endearment* (film), 23
Texaco, xiv–xv
Tharp, Twyla, 138
theater: Daniels and, 21–22; Gupton
    and, 101–3, 106; history of,
    1–2, 4–5; Miranda and, 43–53;
    Shakespeare and, 1–9
*Too Hot to Handel,* 92
touring: Davis and, 136; Greenwood
    and, 84–85; Marsalis and, 136

uniqueness: Jones and, 31–32; Miranda
    and, 53
University of Michigan, xiv
unschooling, 57

versatility, Shakespeare and, 4–5, 8
*Violin Concertos by Black Composers of
    the 18th and 19th Centuries* (Pine),
    61
vulnerability, Jones and, 40

Welk, Lawrence, 32
Welk, Lois, 35–36
Wesleyan University, 46–47
Wilde, Oscar, xviii
Williams, John, 99–100
Wilson, Lanford, 22
Wolfensohn, James, xiii–xiv
work/work ethic, x, xx; Daniels and,
    21–22, 26, 28; Marsalis and, 139;
    Shakespeare and, 6
World Bank, xiii–xiv

Young, Simone, 96

Zane, Arnie, 33–38
Zhang, Xian, 96

158

# About the Author

**Aaron Dworkin** is the immediate past dean and a tenured professor of arts leadership and entrepreneurship at the University of Michigan's School of Music, Theatre & Dance, as well as a professor of entrepreneurial studies at the Stephen M. Ross School of Business at the University of Michigan.

Dworkin is the founder of the Sphinx Organization, the leading international arts organization with the mission of transforming lives through the power of diversity in the arts. He also founded the Dworkin Foundation, where he serves as chairman of the board.

He is also the producer and host of AaronAsk, a weekly online mentoring show on creativity and leadership. A multimedia performing artist, author, social entrepreneur, artist-citizen, and educator, he continually receives extensive national recognition for his leadership and service to communities. In addition, Dworkin serves as the founder and president of the Ginbo Cup for black and Latinx eSports athletes and is a practicing visual artist with multiple showings of his *Fractured History* exhibit.

Named a 2005 MacArthur Fellow, President Obama's first appointment to the National Council on the Arts, and Governor Snyder's appointment to the Michigan Council for Arts and Cultural Affairs, Dworkin is a sought-after global thought leader and a passionate advocate for excellence in arts education, inclusion entrepreneurship, and leadership. He is a frequent keynote speaker and has been featured in *People Magazine* and on NBC's *Today Show* and *Nightly News*, CNN, and NPR's *The Story* and *Performance Today*. He has been the subject of articles in *The*

*New York Times*, *Chicago Tribune*, *Detroit News*, *Detroit Free Press*, *Washington Post*, *Chronicle of Philanthropy*, *Emerge*, and *Jet* and was named one of *Newsweek's* "15 People Who Make America Great." He is the recipient of the Royal Philharmonic Society Honorary Membership, Harvard University's Vosgerchian Teaching Award, National Governors Association 2005 Distinguished Service to State Government Award, Detroit Symphony Orchestra's 2007 Lifetime Achievement Award, *Detroit News's* 2003 Michiganian of the Year Award, Crain's 40 Under 40 and Who's Who Awards, BET's History Makers in the Making Award, AT&T Excellence in Education Award, and National Black MBA's Entrepreneur of the Year.

Dworkin serves as a board or advisory member for numerous influential arts organizations including the National Council on the Arts, Michigan Council for Arts and Cultural Affairs, National Association of Performing Arts Presenters, the Avery Fisher Artist Program, Independent Sector's Advisory Group, National Society for the Gifted and Talented, Rachel Elizabeth Barton Foundation, editorial board of *Downtown New York* magazine, and Chamber Music America. As the co-chair of the Arts and Cultural Education Task Force for the State of Michigan, Dworkin designed the required arts curriculum for Michigan schools.

A lifelong artist, Dworkin is active in the visual and spoken-word spheres. He is represented by Jensen Artists and has collaborated with a breadth of artists including Yo-Yo Ma, Damien Sneed, Anna Deveare Smith, Damian Woetzel, Lil Buck, and others. He recorded and produced two CDs, entitled *Ebony Rhythm* and *Bar-Talk*, in addition to writing, producing, and directing the independent film *Deliberation*. His visual art show *Fractured History* will be exhibited in Ann Arbor and Detroit, Michigan, during the 2019–2020 season.

As a successful writer, he has authored a poetry collection, *They Said I Wasn't Really Black* (1999); a children's book, *The 1st Adventure of Chilli Pepperz*; a science-fiction novel, *Ethos: Rise of*

*Malcolm* (2018); and a memoir titled *Uncommon Rhythm: A Black, White, Jewish, Jehovah's Witness, Irish Catholic Adoptee's Journey to Leadership* (2011).

In his spare time, he enjoys politics, debate, culinary and cinematic arts, and travel. Dworkin is married to Afa Sadykhly Dworkin, a prominent international arts leader who serves as president and artistic director of the Sphinx Organization. He has two awesome sons, Noah Still and Amani Jaise.